Jacques Derrida

Deconstruction Engaged

The Sydney Seminars

Jacques Derrida

Deconstruction Engaged

The Sydney Seminars

Edited by
**Paul Patton and
Terry Smith**

POWER PUBLICATIONS
SYDNEY

Published by
Power Publications
Power Institute: Foundation for Art and Visual Culture
The University of Sydney NSW 2006
Australia

General Editor
Julian Pefanis

Managing Editor
Greg Shapley

Printed by
El Faro Printing

Cover design by
Greg Shapley from an image by Anne Zahalka

National Library of Australia Cataloguing-in-publication entry

Jacques Derrida : deconstruction engaged : the Sydney seminars.

ISBN 1 86487 433 3.

1. Derrida, Jacques - Congresses. 2. Deconstruction - Congresses. I. Patton, Paul. II. Smith, Terry.

149

CONTENTS

Introduction

Jacques Derrida's two Sydney seminars of August 1999 provided an opportunity for him to present some of the principal themes of his work to a non-specialist audience. The texts published here are reconstructed from the transcripts of those sessions. They provide clear, systematic and highly accessible introductions to many of the central concerns of Derrida's engagement with philosophy, visual art and politics. Warmth of feeling and openness of spirit pervaded both occasions, precipitated not least by the degree to which Derrida so evidently embodied these qualities in himself. His extraordinary generosity of spirit and willingness to engage with both interlocutors and audiences ensured the overwhelming success of these events. This mood inspires the texts that follow.

The first session took the form of a discussion of aspects of his work relating to the visual arts with Terry Smith. This event, entitled "Deconstructing Vision," was held in the Sydney Town Hall before an overflowing audience of more than 2,000 people. An unknown and uncountable number of others were able to access the online broadcast of this event. At the second seminar, which took place the following day at The University of Sydney's Seymour Centre Theatre, Derrida responded onstage before an audience of more than 600 to questions put to him by a panel consisting of the

philosophers Genevieve Lloyd, Paul Patton and Penelope Deutscher, as well as his friend and translator David Wills.

Until this trip to Melbourne and Sydney, Australia was the only continent to which Derrida had not traveled. His visit was long anticipated, both among the many present and former students of his work in Australia and in Derrida's own itinerary. In a letter written to Catherine Malabou in February 1998, and published the following year as part of her book about the "voyages"—in every sense of the word—of Jacques Derrida, he refers to his impending visit to South Africa in the (northern) summer of 1998 and to his projected visit to Australia in the following summer. He goes on to suggest that the Australian trip might be undertaken expressly in order to overflow the borders of Malabou's book. As this book deals only with his travels up until 1999, Derrida's remarks—indeed, his trip to Australia—thus falsify the widespread misrepresentation of his philosophy as a form of textual idealism according to which text is all there is.[1]

In fact, in Australia as elsewhere, Derrida's presence had made itself felt over the previous thirty years. His work had been taken up, commented upon and criticized in disciplines throughout the humanities and social sciences. Philosophers in Sydney who had never read his work were moved to join protests against his being awarded an honorary doctorate by the University of Cambridge.[2] Theorists more sympathetic to his work had prevailed upon him to make a spectral appearance on screen via satellite at a conference on Artaud held at the University of New South Wales and elsewhere in Sydney during September 1996.[3] Against the background of this widespread interest in his work, and following a series of efforts to entice him to make the voyage in person, Professor Derrida accepted the invitation of his friend, poet and academic, Professor Kevin Hart, Director of the Centre for Comparative Literature and Cultural Studies at Monash University in Melbourne.[4] The Power Institute, Foundation for Art and Visual Culture at the University of Sydney was delighted to join the Monash Centre as co-sponsor of Derrida's visit. Dr Alan

Cholodenko from the Power Institute was instrumental in making this event come to pass and a success, including his formal Introduction of Derrida at Sydney Town Hall. The ensuing events inspired much commentary on the radio and in the press, not all of which followed predictable lines about the incomprehensibility of a style of thought supposedly beyond the reach of ordinary listeners and readers. One columnist was moved to speculate on reporting itself as a kind of public philosophising, by both journalists and readers, about how we know what we know.[5]

The first of the seminars, "Deconstructing vision," was shaped as an introductory survey of Professor Derrida's thinking about matters visual. Certain of his books, notably *The Truth in Painting* and *Memoirs of the Blind*, take as their starting point artistic perception and the ways in which it has been understood and theorized. Extended discussions of the visual arts also occur in chapters of books devoted primarily to other, related concerns. Commentary about the nature of vision and its relation to knowledge and representation is a constant feature of much of his work. The session sought pathways through this material by approaching it in three parts. 1. Interrelationships between writing (*écriture*) and modes of visualisation, between practices of reading, envisioning and knowing. 2. The figure of the artist. What is it to see, know, read, represent? 3. The visual/textual cultures of mass media—advertising, film, television, the Internet.

Professor Derrida agreed to respond to three sets of questions under these headings. Each set was introduced by a preamble, and both had been sent to him a few weeks earlier. He had had time to prepare a written response to the first set of questions, which he read out, adding some extempore comments. His original handwritten text was used as the primary reference for the transcript, with additional comments transcribed from the audio and videotapes. These latter provide the entire source of transcription for his comments on the images used in *Memoirs of the Blind*, and for his responses to the second and third sets of questions.

Part 1 "In Blind Sight: Writing, Seeing, Touching..." provides a rare, concentrated summary of Derrida's thought on questions of the relative value of vision and language in relation to knowledge. He shows the limitations of the view that there is a "denigration of vision" in recent French philosophy. New is the way he insistently compares knowing through seeing to knowing through touching—the subject of a book since published, *Le Toucher: Jean-Luc Nancy*.[6] And many of the comments on images of artworks discussed in *Memoirs of the Blind* add subtle touches to his remarks on them in the text of that book.

Part 2 "The Artist, The Projectile" focuses on the figure of the artist as creator, generator of visual images, projector of perceptions. Derrida discusses the differences between the approaches of Valerio Adami and Antonin Artaud, and the relative value of "the real" and "the impossible" in understanding practices of representation. The concept of the subjectile is explored in comments on a number of drawings by Artaud, following Derrida's earlier essay "Unsensing the Subjectile,"[7] and in some highly suggestive remarks on the painting of Jackson Pollock.

Part 3 "Specters of Media" takes up the question of whether mass media is our contemporary form of spectrality. Derrida refers to his tracing, in his book *Specters of Marx*, of the specters of mourning which have haunted capitalism since the collapse of communism. He goes on to posit an ethics of practice in the mass media today, and in the relations of intellectuals to the media. A striking instance occurred at his Melbourne press conference, when he was asked to comment on the Australian Government's refusal to proffer an apology to Aboriginal peoples for past mistreatment. He discusses this incident illuminatingly in the text that follows.

The second seminar, "Affirmative Deconstruction," was conceived as an occasion for members of the panel to engage Professor Derrida on themes from his recent work. As before, a draft of the questions was sent to him in advance. He responded to these questions in English and without notes. By recent work we

meant primarily texts published since 1990. This arbitrary limit was chosen in order to focus on what is often called "deconstruction in its affirmative phase," since is now more widely understood that deconstruction is not—if it ever was—a purely negative enterprise. Derrida has always insisted that deconstruction, if there is such a thing, is not a systematic theory, a project nor a formalisable method of analysis. Rather, it is one among many possible metonymic names for what happens or doesn't happen, not only within philosophical texts but also within experience more generally.[8] As such, his deconstructive analyses amount to a series of encounters with particular texts, contexts and phenomena in which certain characteristic features of experience, thought and "writing" are displayed, in particular the irreducible movement of repetition and difference, same and other, singularity and universality. It is this double movement that is named in the iterated series of neologisms that includes *différance*, dissemination, the trace, spacing and so on.

The mobilisation of these and other terms, intended to demonstrate the instability of borders and all forms of identity, led many critics to suppose that deconstruction remained an entirely negative gesture which refused all forms of closure in favour of an open-ended but indeterminate space of possibilities. Against this widespread view according to which *différance* meant only deferral, delay and postponement but never decision, Derrida's recent work insists on the affirmative dimension of the passage through undecidability which conditions every decision, every action and every event: "In the incoercible differance the here-now unfurls. Without lateness, without delay, but without presence, it is the precipitation of an absolute singularity, singular because differing, precisely and always other..."[9] Through analyses of phenomena such as mourning, inheritance, religious faith, technology, justice and hospitality, Derrida's recent work affirms the possibility of both continuity and rupture with the past, both the maintenance of tradition and the invention of the new. Through an approach to the nature of time

and to events from the perspective of an open future, described in terms of the "to-come" (*à-venir*), or a messianism or messianicity without a Messiah, Derrida affirms both the openness of the future and the necessity of decision, of responsibility for the acts and events through which the future comes.

A feature of deconstruction in its affirmative phase is Derrida's willingness to engage directly with overtly political themes. The idea of Europe and national identity, the legacy of Marx and marxism, justice, democracy and the politics of friendship are just some of the themes addressed since 1990. This does not mean that deconstruction has become, or that it will lead to, a political program, but rather that it provides a way of thinking about the conditions of political invention and, as Derrida specifies in his response to Penelope Deutscher, the conditions under which progress in human affairs is possible. One such condition is the unavoidable recourse to certain undeconstructible entities in terms of which or by reference to which the deconstruction of established institutions, codes and forms of thought always takes place. These undeconstructibles are paradoxical entities of the kind made familiar by earlier deconstructive analyses of undecidability, iterability and aporia from at least his discussion of Aristotle on time in *Margins of Philosophy:* an impossible mourning, an atheistic religiosity, justice, unconditional hospitality and so on.

The contradictory nature of these undeconstructibles relates to the sense in which deconstructive acts or processes necessarily involve aporias. They are subject to contradictory exigencies. For example, a decision is not really a decision if it is simply programmed or determined by laws, conventions and rules. On the other hand, it would be difficult to accept as a decision, and certainly as a responsible decision, any act or choice that bore no relation of any kind to rules or conventions. In this sense, a decision is an impossible event, yet also something that happens all the time. Every decision, Derrida argues, involves this paradoxical moment of undecidability: "Each time a responsibility (ethical or political)

has to be taken, one must pass by way of antinomic injunctions, which have an aporetic form, by way of a sort of experience of the impossible; otherwise the application of a rule by a conscious subject identical to itself, objectively subsuming a case to the generality of a given law, manages on the contrary to irresponsibilise, or at least to miss the always unheard-of singularity of the decision that has to be made."[10]

A first aim of the Seymour Centre discussion was to show some of the continuity between deconstruction in its affirmative phase and Derrida's earlier writing. To this end, Genevieve Lloyd points to his recurrent challenge to the common understanding of time which privileges the present moment and which reappears throughout the history of philosophy from Aristotle to Husserl. In a similar vein, David Wills points to the connection between the kinds of conjoined possibility and impossibility that recur in Derrida's aporetic analyses and his earlier discussions of the disseminative and iterable nature of language and communication.

A second aim was to examine, from a variety of angles in a range of contexts, some of the varieties of aporetic injunction analysed in Derrida's recent work. Thus, Genevieve Lloyd asks about the possibility and impossibility of mourning analysed in *Memoirs for Paul De Man*, and about the nature of the messianicity that characterises our relation to the future. David Wills raises the aporia involved in inheritance of any kind, including the inheritance of the past involved in any form of technology, and on that basis asks whether we can envisage an affirmative relation to technology. Paul Patton asks about the aporia involved in doing justice to others, especially in colonial contexts, its relation to other concepts of justice and to the aporia involved in translation from one language to another. Penelope Deutscher explores the aporia involved in hospitality and its relation to culture and to the idea of amelioration or perfectibility.

Finally, just as many of Derrida's recent texts address issues of immediate political concern in France and Europe at the present

time, so many of our questions refer directly and indirectly to issues which relate to Australia's faltering efforts to dissociate its political institutions and public attitudes from its colonial past. These questions address the nature of colonialism, the possibility of justice for indigenous peoples, the nature of responsibility, especially the responsibility of the present generation for consequences of past colonial policies, and the forms of hospitality which might be envisaged in the future. Indeed, Derrida's remark from *The Other Heading* is an appropriate aphorism to introduce the discussions reproduced in Part II below: "I would even venture to say that ethics, politics and responsibility, if there are any, will only ever have begun with the experience and experiment of the aporia."[11]

We are delighted to acknowledge the following people for their contributions toward the visit of Professor Derrida and to this publication. Professor Kevin Hart; Dr Alan Cholodenko and Dr Julian Pefanis of the Department of Art History and Theory; Professor Margaret Harris, Director of The Research Institute for Humanities and Social Sciences; Professor Gavin Brown, Vice-Chancellor of the University of Sydney; Brendan Harkin of Australia Online; the National Office for the Information Economy, for sponsoring and organising the webcast through ABC Online; staff of the Power Institute of Fine Arts, particularly Helena Poropat, Elisabeth Schwaiger and Greg Shapley; staff of the Research Institute for Humanities and Social Sciences, University of Sydney, particularly Rowanne Couch, Erica Seccombe and Melissa McMahon; Yoram and Sandra Gross; Dr Penelope Deutscher, Professor Genevieve Lloyd and Professor David Wills; the Director of the Seymour Centre, Ann Mossop, and her staff; and Gleebooks, who were also sponsors of the second seminar. Finally, we are especially thankful to Professor Jacques Derrida for his generous participation.

Paul Patton and Terry Smith, Sydney, February 2001.

Notes

1. Catherine Malabou and Jacques Derrida, *Jacques Derrida: la Contre-Allée*, Paris: La Quinzaine Littéraire and Louis Vuitton, 1999, p.269.
2. See the appendix to 'Honoris Causa: "This is *also* extremely funny"', in Jacques Derrida *Points ... Interviews, 1974-1994*, ed. by Elisabeth Weber, trans. Peggy Kamuf et al, Stanford: Stanford University Press, 1995, pp.419-421.
3. The conference was organised by Alan Cholodenko, Jane Goodall, Edward Scheer and Nicholas Tsoutas. Proceedings have since appeared in Edward Sheer ed., *100 Years of Cruelty: Essays on Artaud*, Sydney: Power Publications, 2000.
4. During his visit to Melbourne, Jacques Derrida presented a lecture, "Forgiving the Unforgivable", and conducted a roundtable discussion with Monash University staff and postgraduates on "The Nature of the University". He also attended an exhibition of artworks entitled "Beyond the Book: Homage to Jacques Derrida," at the Victorian College of the Arts.
5. Mackenzie Wark concluded his column about the Sydney Town Hall discussion with these thoughts: "Artaud's violent, sexual, clumsy drawing might seem far removed from the daily TV news. But perhaps it is already a commentary on what the news has become—our theatre of cruelty. Derrida's complex, subtle thought might seem far removed from *Neighbours* on TV—but the word 'deconstruct' was uttered on that show this week. The problems of signs and their significance, the problem of knowledge and how we know it, are not esoteric or academic—they are everyday life", *The Australian* August 18, 1999.
6. Jacques Derrida, *Le Toucher: Jean-Luc Nancy*, Paris: Galilée, 2000.
7. In Jacques Derrida and Pale Thévenin, *The Secret Art of Antonin Artaud*, trans. Mary Ann Caws, Cambridge, Mass: MIT Press, 1998.
8. See, for example, Jacques Derrida, *Points ... Interviews, 1974-1994*, p.356.
9. *Specters of Marx: The State of the Debt, the Work of Mourning, and the New International*, trans. Peggy Kamuf, London and New York: Routledge, 1994, p.31.
10. Derrida, *Points ... Interviews, 1974-1994*, p.359.
11. Derrida, *The Other Heading: Reflections on Today's Europe*, Bloomington and Indianapolis: Indiana University Press, 1992, p.41

I

DECONSTRUCTING VISION, Sydney Town Hall, August 12, 1999

Jacques Derrida

in discussion with Terry Smith

In Blind Sight: Writing, Seeing, Touching...

Terry Smith – Preamble and questions

What follows from the deconstruction of the widely held premise that vision—seeing and knowing, knowing as seeing—is at the heart of Western thought? The spread of scientific knowledge, the very practice of rationality, has often, since the 18th century, been metaphorised as "The Enlightenment." Much earlier, Plato inaugurated a brilliant metaphor of what it is to come to know as a turning away from false reflections towards truth, in his analogy of those who broke the chains of the cave and stepped out into the blinding light of the sun. Centuries later, in our time, pictures of all kinds, mainly photographs, dominate public sphere communication, visual languages saturate contemporary society, spectacles gather crowds consistently (as we see here tonight), politicians peddle their public image...so, taking all that together, the cultures of modernity seem *prima facie* to be predominantly visual.

Since the early 1960s you have developed a substantial critique of this structure of thought, which you call "logocentrism," of its tendencies to universality, to totality, of its reifications, its apparent certainties—indeed, you highlight its "metaphysics of presence," the paradox that its fundamental claims for materiality

are themselves abstract presumptions (or, in your term, "transcendental signifiers").[1] Does it follow, then, that you reject the centrality of vision—and sound, of course—in favour of the priority of a broad concept of spoken and written language? Many commentators insist that you insist that "Everything is a text," that "There is nothing outside of the text." Wildly generalising from the specifics of the context in which you made this comment, they take you to be posing the priority of language over vision, indeed, over everything else that might exist or be thought.[2]

In my view, this account repeats the binary closures of which your work is a highly developed critique. It places word and image, art and text, into implacable opposition. Yet your writing about writing constantly treats this relationship as one in which *écriture* (speaking, writing, sounding in all their connected senses) is always in a complexity of relationships with visual imagining— for example, in the wonderful essays on Mallarmé.[3] Equally, your explorations of the operation of vision and of the work of a number of visual artists—both of which we will discuss tonight—show that these are deeply implicated in the operations of language.

Can we take a specific instance of this? In the book *Memoirs of the Blind, The Self-Portrait and Other Ruins*, you explored the idea that the act of drawing necessitates a moment of not-seeing, that artistic representation proceeds by obliterating marks of memory, while yet leaving traces of memory, particularly in the self-portrait.[4] This implies that visual art is most interesting when it occurs as a play between light/dark, seeing/not seeing, visibility/invisibility, between, that is, vision/blindness. The problem is to come to know these couplings in a sense beyond binaries, like "light" or "dark," more perhaps as fissures, mutualities, antagonisms, interplays.

Here ends the preamble. I come now to the questions that I have on this topic.

Could you please describe for us this interzone, this set of relationships between modes of writing and modes of visualising, particularly those connected with desires to know (these might be called practices of *envisioning*)? Is not the concept of reading as distinct from that of seeing of pivotal importance to this question? A related issue: is visual art always and only a particular form of writing (in the sense of *écriture*)? Let me put this last question in an even more concrete way—perhaps in a modernist manner (as one would expect, given the history of concerns here at the Power Institute): there is, in certain abstract painting, in minimal sculpture's fondness for the title *untitled*, and in some conceptual projects, a drive to escape discourse all together. The desire in each case—to take them in turn and in the language of their moments— was for pure opticality, utter materiality, and dematerialisation.[5] Are such desires always destined to be detours between art and the world? If so, why do they persist, keep on coming back in one guise or another? Is the drive for pure opticality, for example, a thirst for blindness, or at least a kind of bedazzlement? Is it a desire for a kind of seeing without knowing, or at least a kind of knowing that is so transparent that it doesn't require a translation back into the world—as if it was, oddly, an enlightenment, perhaps a *satori*, of some kind?

Jacques Derrida:

I would like first of all to thank the Vice-Chancellor and Alan Cholodenko for their introductory words, and you Terry. Before I even try to answer these formidable questions, before I fail, because I am going to fail and give up answering such questions in this situation—let me tell you, all of you here in this great hall, and first of all my hosts at the Power Institute, how honoured, touched and moved I am by this invitation and all these generous signs of hospitality. Even if this situation is intimidating and threatening to me, having to face these huge and complicated questions and to more or less improvise an answer—or, rather, a quick reaction—in a foreign

language that I do not, as you can hear, control, and do so in front of the demanding crowd that you are. This audience, I understand, is not limited to those who are here now. But what does that mean to be here, now? This will be part of the question I am going to ask in responding. This audience is not limited to those who are here now but, virtually, includes an undetermined number of people who could watch us right now all over the world, who perhaps tomorrow will virtually watch again the virtual archive of what will have been my failure to answer and my failure to speak a foreign language.

This virtuality, which implies prosthetic technology, might also be a decisive element in my poor answer. So even if this situation is terribly intimidating and threatening to me, let me tell you again before I start how again grateful, moved and touched I am by your presence, by this vigilant attention, by this invitation and by this hospitality.

Now, why do I say, and what drives me to say that I am thus moved and touched? How can I say that? Obviously, nothing and no one moves, and certainly no one touches me here, literally speaking. If I say that I am touched, and to the extent that you understand what that means—in this case it is easily translatable between French and English, to be touched and moved—many people would agree that this consists in using a trope, a metaphor or a metonymy. This rhetoric has a long and layered history in our culture, in our cultures, indeed, in many cultures. It certainly conditions or structures the philosophical language, the theoretical language we use. Theory itself, the word and the concept of theory itself, is dependent on a rhetoric of visualising, visuality, vision, seeing, optics. To theorise means, as you know, to see, to contemplate, to gaze, as in *theoria*. This rhetoric moves in what you call the interzone between different modes of perception, of senses, of sensible perceptions.

So why do I start with touching in this context? Before I try to address precisely your question about visualising and writing, seeing and reading, visual art and writing, let me go back for a

moment to what you said in your preamble about the premise, which is now a common assumption, namely that vision or seeing, and knowing as seeing, is understood to be at the heart of Western thought. You mentioned the Enlightenment, Plato, and today everything which in our culture seems to be predominantly visual. At this point I would like to explain why I started with this remark on touching. I would like to complicate these accounts which are so commonly given today concerning the prevailing authority of the visual, seeing, the optical, etc. How could I proceed now to complicate this common account of an allegedly common assumption? You see—*you see!*—I have been all my life struggling with this question, so that providing the answer today is all the more difficult.

When we agreed on this contract and said this should not be a lecture but a sort of quasi-conversation or discussion, I thought of it occurring in a small group of people, with interruptions and elliptic agreement on about what goes without saying in a more or less familiar or common domain. I was imprudent enough not to realise how impossible the task would become when I would have to address such a large audience, not knowing what is familiar, well known, or totally unknown to part of this audience. So the only possible thing I can try to do is to proceed in the dark, to try to explain first why this common assumption has to be challenged and complicated, and second what my response or strategy may be in front, or in the middle of these complications.

First, of course, there are a number of signs that seem to confirm the common assumption, they are the ones that you recall: Plato, the Enlightenment, the domination of current culture by the image, and so forth. We might add to these the tendency, from Plato to, say, Husserl, to grant privilege to the *eidos*, or idea, which means in Greek, as you know, the visible form, the visible contour of what is. Being (*ta onta*), real being, is interpreted as *eidos*, as something visible in a sensible or intelligible fashion. There is here a reference to the *phenomenon*, to the *phainesthai* as something that appears in the brilliant light. Phenomenology is relevant, it being

the science of what appears, as such, in its appearance. So is the authority granted to *lumen naturale*, "natural light," by Decartes for instance. For him, the truth given within this element of natural light was a truth not subject to radical doubt. Then also the privilege granted to what one calls intuition, to the *intuitio*, which means, as you know, "I see."

All of these signs seem to confirm the current assumption about modernity. The contemporary development of visual culture would, then, no doubt, be the legitimate continuation of this exorbitant privilege of the eye. But here is the first complication: it already exists in Plato's discourse—to go back as early as possible. Light itself, the sensible, or, first of all, the intelligible which conditions the *eidos*, the intelligible sun, *agathos*, the good, as the source, the father and the capital—these are Plato's figures and metaphors, the father and the capital of visibility, the intelligible sun which makes things visible.[6] The complication is that this source of visibility must remain invisible.

This can be easily accounted for by common sense. The visibility of the visible—that which makes the light visible, its condition of visibility—is not itself visible. That is to say, the visibility of the visible is not visible. So, there is a night, a darkness within the very transparency of the *phainesthai*, of what appears, of what makes things appear, of what is in front of me as visible. Merleau-Ponty, in his book *The Visible and the Invisible*, shows that the invisible is not simply a part of the visible, it is not merely a visible to come, a potential visibility to be reached, or something left to be seen.[7] On the contrary, the invisible is included within the experience of the visible. As well, the intangible, the untouchable, is also included; they belong to the structure of the touchable. Let me read, if I may, a passage in Merleau-Ponty that makes this clear. He wrote it in January 1960, and it was published only after his death. I quote it in *Memoirs of the Blind*.[8]

Principle: not to consider the invisible as an *other visible* 'possible,' or a 'possible' visible for an other...The invisible is *there*

without being an *object*, it is pure transcendence, without an ontic mask. And the 'visibles' themselves, in the last analysis, they too are only centered on a nucleus of absence:—
Raises the question: the invisible life, the invisible community, the invisible other, the invisible culture.
Elaborate a phenomenology of 'the other world,' as the limit of a phenomenology of the imaginary and the hidden.[9]

And in May 1960 he made these further notes:

> When I say that every visible is invisible, that perception is imperception, that consciousness has a *'punctum caecum,'* that to see is always to see more than one sees—this must not be understood in the sense of a *contradiction*—it must not be imagined that I add to the visible...a nonvisible...—One has to understand that it is visibility itself that involves a non-visibility.[10]

He goes on to describe the same structure for touching and the untouchable.[11]

Now, this intrinsic implication of invisibility in the visible does not, of itself, endanger the absolute authority of the visual. This authority has been noted by many people in different ways, including myself to some extent, with certain reservations to which I will return later. The first one in this century to say something profound about this dominant assumption in Western culture may well have been Heidegger. In a famous passage in *Being and Time* he said that "the idea of the *intuitio* has been leading every interpretation of knowledge, from the very beginning of Greek ontology up to now, whether this is accessible or not."[12] *Intuitio* includes the gaze, looking and seeing, *sehen*. You will find analogous claims in France, in Blanchot, Levinas and so on. So there may have been a growing suspicion toward vision in some French thinking, what Martin Jay calls in his book—I read the title—*The Denigration of Vision in 20th Century French Thought.*[13] One might think that some deconstruction should be linked to this deconstruction/denigration of vision.

Now the second complication occurs. Things are not that simple. Not only because invisibility is the medium of the visible, but also because the dominant authority of the *intuition* (of the intuitionism which is to me the very essence of philosophy, beyond the debate, the mirroring, between intuitionism and formalism, and so on), the authority of intuitive knowledge has not, never has been, simply the authority of vision, of seeing what is visible, as sensible or as intelligible. It also involves *touching*, the assumed immediacy of contact.

In the texts of all of many philosophers that I have mentioned—from Plato to Decartes to Berkeley to Bergson and Husserl—the fullness of the intuition, of the knowing intuition, implies literally or figuratively an experience of touching. In Plato's *Republic* the soul is said to have to touch (*haptein* in Greek, to fasten on to) the truth. We could quote a number of such statements in Kant, Descartes, Bergson, and Husserl. The case of Husserl is even more striking because, while he is constantly devoted to the conversion of the gaze to the eidetic, to phenomonality and so forth, he insists in a book entitled *Ideas II* on the absolute privilege of touching, and especially on touching oneself touching, of the touched—touching body as the only possible experience of the body, of the living and proper body, of *das Leib* in German, or *corps propre* as we say in French.[14] This is a possibility he firmly denied to seeing: you cannot see yourself seeing, he claimed, in the way you can touch yourself touching. You can touch your right hand with your left hand, for instance, and feel it happening. In my book *Le Toucher: Jean-Luc Nancy*, I note that it is closely associated with the history of the hand, the interpretation of the human hand.[15] The topic of the hand is also very present in *Memoirs of the Blind*.[16] You cannot see yourself seeing because, even in a mirror, you can see your eyes as *seen* but you cannot see your eyes as seeing. Thus you cannot see yourself as yourself seeing through an immediate intuition of self. Rather, you see yourself as an other through the phenomenon of indirect representation (*Einfühlung*).

I cannot reconstitute all the difficulties involved in this analysis, of Merleau-Ponty's interpretation or misinterpretation of it, the way he tries to reconstitute the parallelism between seeing and touching in the experience of what he calls flesh, the body, *le corps, le chaire*. I cannot address here all the problems that the reading of these texts and their tradition may involve. To do so would require a long development, in which one would read from that point of view not only the canonical texts but also the Bible, the Gospels. In the Gospels, of course, the authority of light, of revelation, is obvious. The drawings I select for *Memoirs of the Blind* are striking in that respect: Jesus Christ is a touching figure, he cures by touching, indeed, he cures the blind by touching. He is not only touching but is himself touched. In Mark and Luke you can find a number of references to the experience of being touched by Jesus as light, and the importance of touching Jesus himself or his dress.

The only thing I can try here is to locate the place where this struggle for the hegemony or the supremacy of one sense over the other, seeing over hearing, seeing over touching or smelling, takes place. The stakes of this struggle are enormous. It is first of all a humanistic struggle for power, privileging the hand/eye relationship in the long process of humanisation. This raises first the question of the animal. Second, it is always caught up in a phenomenology of perception which neglects the prosthetic and technological dimension, which allows not only for a synaesthesia (the collaboration of senses, or the substitution of one sense for the other), but also for the metonymic substitution of one sense for the other. There is an enormous literature on the *touching eye*. You have this idea in Descartes, Berkeley and so on up until Husserl, who actually called it a non-serious metaphor. When he used these expressions, these figures about the eye that touches what it sees, Husserl would say that this is pure metaphor, mere rhetoric and therefore not interesting. Third, this phenomenology of perception ignores the teletechnology, the virtualisation and digitalisation of the field.

So this is why this struggle for power, for hegemony or supremacy, calls for an analysis of the so-called senses, the sensible data or perceptors. An analysis which should integrate from its inception, from the beginning, a taking into account of power as *techne*. *Techne* as art as well as a prosthetic teletechnology in the spectral field of virtuality. I find it fascinating, by the way, that we are currently discussing these things in an institute that is named after an artist named Power.[17]

Our relation, and even our critical, political relation to visual culture today should take into account these complications. They have nothing to do with one sense dominating the other, rather, with another structure of a general technoprosthetic virtual possibility.

This is why from the very beginning—and now I am responding to the second part of your question—a long time ago I started trying to elaborate a concept of writing, of trace, of *différance*, *gramme*, or *other* reading which should be as foreign as possible to this endless competition between the so-called intuitive senses (spatial or temporal: seeing, touching, hearing). By insisting on *spacing* (on *espacement* in the spatial as well as the temporal dimension) as an interval of conjunction/disjunction, as interruption, and by reference to another trace (without the intuitive fullness of presence required by the traditional concept of seeing as contrasting), I tried in fact not to denigrate vision, nor indeed space, as Martin Jay has supposed we are all doing in France in the 20th century.

I then tried to open a space, a spacing where even sound, the voice and the tactile impression—"the optical," as one says—should be and could be interpreted as *traces*, according to another, broader and more differentiated concept of writing-reading (*écriture*).

And, third, I tried to inscribe within this the very structure, the possibility or necessity of the prosthetic as technological and rhetorical supplementarity, substitution, and so on.

From that point of view, no doubt, *reading* does not mean seeing, more than hearing or touching... And, no doubt, what one

calls visual art is a form of writing which is neither subjected in a hierarchical manner to verbal discourse nor to the claim of authority that logocentric philosophy would like to confirm over the non-discursive arts. Visual art is never totally "pure," never free of traces, which, implicitly or not, inscribe the possibility of phonetic or even verbal discourse in the most visual and the mute aspects of so-called visual art. I am responding here to the last part of your question. No doubt there is a drive to pure opticality, you can see this in a number of examples. There is, as well, a counter drive to pure hapticality, even to pure sonority. But all of these drives are doomed to fail, to ignore their own driving possibilities, so to speak. What drives them is a spacing, a *khora* that prevents them from reaching their purity.[18] This obstacle, this limit to the pure and full plenitude and fulfillment of this drive (be it optical, haptic or musical), is not a negative failure nor is it a threat. It is also a chance, an opening of the desire of the drive. This obstacle is the condition of possibility of the drive itself.

TS: You have read from the book *Memoirs of the Blind* which is based on an exhibition which you were invited to curate at the Louvre in Paris in 1991. There is a fascinating story about the circumstances, which adds a personal touch to the narrative of the critique of vision that you are developing. Would you mind relating that to us?

JD: I am not very good at telling stories, but I will try. I was invited to open this series of exhibitions, the format being that someone who was foreign to the profession of curatorship would choose a theme, choose a number of drawings within the collection of the Louvre and write a text for the catalogue.[19] So I accepted, but had no initial concept. At the moment I had my first appointment with the curators I fell ill, and developed a paralysis of part of my face due, it turned out, to a virus, called "paralysis a frigore." Suddenly, I couldn't close my eye, I couldn't smile, I couldn't eat—it was a terrible expe-

rience. So I had to postpone the appointment. In the mean time, between this moment of the postponement and the next appointment, I had a terrible dream. I tell this part of the story in the book, because it is about the self-portrait, so I play out involving myself in the treatise of the catalogue. During the dream I saw two old, blind people struggling with one another, close to me. Suddenly, one of them was threatening me with a stick and I realised that he was perhaps not really blind but pretending to be blind. He had a half-open eye. The threat, the blackmail they were practicing on me, was aimed against my sons. So there I was, with the problem being actually half-blind, and threatened by half-blind people in my dream. Finally, the illness disappeared: after two weeks I went to my appointment. While driving there in my car I had the idea of the title and of blindness as the theme of the exhibition. Then I went looking for drawings having to do with seeing or not seeing, with the processes of vision, with glasses and mirrors and a lot of related things.[20]

TS: Thank you. At this point we will project onto the large screen behind us on the stage here some of the images that Professor Derrida used in the book *Memoirs for the Blind*, and invite him to discuss them.

First, a sketch by Antoine Coypel, *Study of the Blind*, 1684. It is related to a large painting titled *Christ's Healing the Blind of Jericho* (Chatreaux Covent, Paris, now lost). The artist is picturing the seekingness of a blind person—clearly, from what you said tonight, this is a seeking for touch. In your essay in the catalogue, you say that for an artist to draw a blind person is not only to inevitably create a self-portrait but is also, in effect, to draw the art of drawing in the act of drawing. This is an instance of your larger insight that drawing has at its core a moment of not-drawing, not-seeing, indeed, of blindness.[21]

JD: In this series of drawings by Coypel there is something which is beautiful to insist on—that is, precisely, the hands which are like

eyes. They are the seeing eyes of the blind man; the hands are as interesting as the eyes. But what I tried to show in the book, to summarise it very roughly, is that each time a painter or an artist chooses blindness as his theme, he is, indirectly or perhaps unconsciously, also describing or drawing a sort of self-portrait as a blind draftsman; on the other hand, I tried to show how, contrary to what one usually assumes, one is blind in drawing. I try to interpret this blindness on many levels. First, because in the drawing—and I insist on drawing, it is not as simple in painting—the line, that is, the limit that makes a line, is invisible. It is a pure difference that, in fact, you cannot see. That is what I call *quasi-transcendental* blindness: the trace of a line is invisible, it makes things visible around its tracing, its movement, its potentiality, but in itself it is invisible. Then there is another layer which I call *sacrificial*—this allows me to interpret a number of drawings and paintings about blindness in a structure of sacrifice which I leave as far too difficult for improvisation now.[22]

I go on to say that every drawing in a certain way is a self-portrait, a self-portrait of the draftsman as blind. At the same time, a self- portrait is impossible, it is irreducible, it is a drive for self-portraiture that never arrives, never completely succeeds. You can decipher a self-portrait structure in every drawing, but even in what presents itself as a self-portrait—and I examine a series of drawings by Fantin-Latour which are entitled "self-portrait"—the image is not a self-portrait because the author cannot see himself seeing. He can see himself seen, but not as seeing. He has no access to himself as drawing and seeing what he is currently drawing. This means that the only possible legitimisation for calling a self-portrait a self-portrait is the intervention of a third party, the spectator. It is only the spectator who entitles this a self-portrait. Here you have the intervention of language, of discursive language. It is only through a discursive language of a third party that the self-portrait enters an institution in which it is considered a self-portrait. But even then it is not a pure self-portrait, because there is a certain blindness at

work in what one calls the self-portrait, as I have said. *Memoirs of the Blind* is a meditation on a number of drawings, on the eye, glasses, mirrors, blindness, the self-portrait, etc. It is also an ironic account of my own blindness in this quasi self-portrait, what I call the ruin of self-portrait or the self-portrait as a ruin.[23]

TS: Let us look at another drawing by Coypel entitled *The Error*. It shows a blindfolded figure reaching out wildly, almost stumbling. The figure relates to one in the group from another painting, *Truth unveiled by Time*. This concept is significant when thinking about the image. It may refer to an older notion of drawing: that seeing can be, in a sense, unveiled by drawing. Used as an allegory in the painting, it evokes the logocentric notion of seeing as knowledge, with truth occurring at the moment when time arrives at an image. But, in itself, the drawing is more suggestive.[24]

JD: Of course, this kind of drawing can be read—it has to be read, not simply seen—on many levels. For instance, you have an historical reading of this blind man, historical because at the time there were more blind people in the street, more blind people in society. Then there are all these Biblical connotations and remembrances. In the 17th and 18th century this problem was a very burning issue, when the first operations on the eye started to give back seeing to blind people. So you may have a very rich reading of these drawings, but at the same time an internal structural reading which would go back to what the drawing does, what the author does to his drawing. How does he sign his blind man as a blind man, as if he were trying to represent himself drawing? This man in a certain way is doing what the author is doing drawing, that is, finding his way blindly in the dark.

TS: This wash-drawing by Jacques Louis David, *Homer singing his poems*, 1894, illustrates a point you have made about the relationship between sound and image...

JD: There is a whole history of blind poets... What links blind-ness to speaking is, precisely, that when one speaks one is blind. When the title "self-portrait" as a discursive reference enters the scene it is as blindness, because speaking is blind, it doesn't see. There is a whole tradition of blind poets, from Homer to Borges, including Joyce, even Nietzsche, and Milton of course. I try to analyse their texts from the point of view of blindness and poetics.[25]

TS: The next image is by Ludivico Cardi, known as Cigoli...

JD: This is terrible!! (He sees on the screen a projection of his own image superimposed on the drawing by Cigoli and shrinks back in mock horror.)

TS: Oh, this is not you, although perhaps it is appropriate for both of us, for anybody. It is Cigoli's *Study of Narcissus*, 1610. What it connects to in your text is the sense of self-immersion in the image, the total gaze of Narcissus at his reflection, to the point where he disappears into his reflection or at least wishes to do so. Is this a case of blindness, or total seeing, as dazzle or being bedazzled—in this case by oneself?

JD: Blinded by his self-image, yes. Echo is not far away in the text on Narcissus, in the picture she hovers right behind...

TS: And he sees her, or himself in her. In this page from Cigoli's sketchbook, the artist is thinking, visually, of different possibilities, perhaps hinting at the gender transferring to which you often draw attention. On the right, he shows Echo as herself Narcissus, or maybe Narcissa.[26]

You ask, in *Memoirs of the Blind*, "How does one demonstrate that the draftsman is blind, or, rather, that in or by drawing he does not

see? Do we know any blind draftsman?"[27] There have been very
few, I believe, but a number of artists have been deaf.[28] The next
image is from the School of Guercino, made in 1630; it is entitled
Della Scultura Si, Della Pittura No, that is, "Sculpture Yes,
Painting No." It shows a blind sculptor touching a sculpture and, as
you point out, the painting thrown down on the floor of the studio
shows a man walking past two naked women with his hands behind
his back—the blind painter?[29]

JD: There is a dominant tendency to want to make touching the
absolute sense, that is, to understand all the other senses as a kind
of touching. If you think of art—since we are here to link these
ideas with art—it strikes me that there is no art, visual or non-visu-
al, which is not a form, so to speak, of touching. Drawing, of
course, and painting and interpreting music through an instru-
ment... So, there is always touching. There is no *production* of
anything artistic without touching, usually touching with the hand.
But, if I am not wrong, there is no *reception* or *evaluation* of a
work of art through touching. We evaluate, we enjoy, we experi-
ence works of art through seeing, hearing, and tasting and so on
but never by touching. It is a strange situation: production is
always haptic, so to speak, but the reception and the experience are
never haptic as such.

TS: Speaking of touching, I am touching you now because you
have walked so close to the edge of the stage that you might
fall off.

JD: That is what I am aiming to do, as soon as I can find the
English word for it.

TS: Aiming at the edge, the abyss?
 The last image from this sequence from *Memoirs of the
Blind* is a chalk sketch of 1890 by Odilon Redon entitled *With*

Closed Eyes. Maybe this is a portrait of an artist who understands that he himself is a seeing seer, or, better, an unseeing seer? In a sense, it is almost a self-portrait that disappears.

JD: There are a number of portraits of people with closed eyes, sleeping or dreaming or temporarily blind people...[30]

The Artist,
the Projectile

Terry Smith:

What I would like us to do now is shift, through the figure of the self-portrait, to the next topic: the figure of the artist in relation to seeing and knowing. You have written specifically about visual artists on a number of occasions, in *The Truth in Painting*, for example, you write about Valerio Adami, an Italian pop artist. In that text you deployed your concept of doubling, particularly in relation to an art that crossed over between word and image.[31] Many of the artists you write about include words in their work—indeed, some make hardly any differentiation between word and image or, if they do, make very specific differentiations. In some recent studies you have written about Antonin Artaud and have developed a notion of the subjectile, a concept not widely known in this country, so it would be of interest to develop it a little bit tonight.[32] I find it very suggestive because it combines a number of notions. For example, the sense of an artist's projective drive, so it is like a projectile, that sense of projecting one's self. It evokes Freud's notion of projectivity, and thus points to the unconscious drives at work in the creation of art works. At the same time, however, there is a sense of being propelled towards figuring, towards some kind of figuration in one's work.

This is what I want to ask you about: does your understanding of the artist struggling with the subjectile include the idea of a person engaged in self-construction, in acts of self-making, even self-remaking, of trying out selfhoods, or elements of these, in the processes of visual representation? What I am trying to conjure here is not, of course, a standard theory of expression within which an artist has a self and somehow projects the moods of that self through the work of art to the emoting spectator. Nor do I have in mind the Romanticism of artists driven without any sense of control to work in such and such a way. (Although who can evade the traces of these great shibboleths?) Rather, I am trying to draw out from your idea these double senses of being driven and, at the same time, knowing that one is driven, of being shaped and constructing oneself at the same time. You identify these forces in the work particularly of Artaud, and especially in his drawings.

So, with those introductory words, let me put forward my second cluster of questions. Is the play of forces that you have identified in Artaud's very special case a unique event? Or does his example—precisely in its unconstrainedness, its "madness" as it was named—point to a condition of creativity that is usually invisible? I am trying to picture here a terrain *before*, or somewhere *between*, the force of the unconscious drives and the sources of social demand, a moment (sometimes a long moment) in the processes of representing that occurs before figures and images become really clear—again, an interspatial or interzonal fissure— the moment before convention kicks in and before havoc and repetition begin to hold sway. Somewhere in there, I think, your thinking about how the subjectile was "unsensed" in Artaud seems very suggestive. There is another very famous thinker who has pondered these matters: Jacques Lacan has a concept of "the real" which, he argues, occurs between the unconscious and the symbolic phases of articulation. Yet the concept of the subjectile, of practices of projective self-construction, may be a much more flexible way of looking at this matter.

Another way of asking the question of whether or not we can generalise from the case of Artaud might be to evoke your celebrated interplay between the continuous production of difference (which is maybe what is happening here) and various kinds of repetition—that is, the concept of *différance*.[33] Under the heading of repetition leading to difference, art historians are very interested in inherited conventions, how they impact on artists and how artists use them—we are interested in artistic style, in the puzzle of how style operates as a set of constraints and a set of possibilities. So, again, it is an interplay I am asking you to think about.

JD: This is another enormous specter of questions! First of all, in the book you mentioned, my *Truth in Painting*, I do ask questions about drawing rather than painting, referring to what I am saying about the trace. I feel incompetent on painting, so I try to say something on drawing, on the frame, the limit, between the inside and the outside, the signature and the relation between the words—the verbal language—and the drawing itself. So I turn around, so to speak, what turns around the drawing—what limits the drawing as such. This is what your question turns on.

As to Artaud and Adami, of course they are as different as possible, apparently. It was not—it never is—my choice to write on someone. I was asked to do so, I was in a situation of accepting an obligation. I admire both of them differently. It would be wrong to think that Artaud was simply a sort of violent eruption, an undisciplined creator, because when he was young he was as exact and disciplined a draftsman as Adami. If you were to see the works of the young Artaud you would be impressed by his mastery of drawing and the painting. It was only after a certain moment, which he himself situated in October 1946, that everything changed. This does not mean that he lost that mastery or his ability as an artist but that some revolution appeared, which we are going to refer to in a moment. In both cases there is a discipline, a very firm control of the art, and also a passivity. Even in the case of Adami, where self-

control really dominates the manner, he is subject to drives. It would be interesting to decipher just what it is he is subject to. Now, you are asking about the uniqueness of Artaud. Well, of course, every corpus and every work in the corpus is a unique event. But this does not prevent us from paying attention to some analogies, some repetitions. I never oppose uniqueness to repetition. I try to elaborate a logic in which singularity is indissolubly linked to repetition, to the possibility of being repeated, which I call "iterability." There is always repetition within the uniqueness of the event. In the case of Artaud there is projection, too, in the psychological, psychoanalytical sense, more than in Adami. There are not only projections, but also a theory, or rather a systematic experience, of what a projection is. For him, drawing and painting was a way of throwing, of striking a blow—in other words, the projection of a projectile. One can find in many of his drawings the representation of this blow, this projectile, these bullets, sometimes these weapons which are thrown on the subject, on the canvas, on the surface. You refer to the language in which he describes his relation to drawing, painting and poetry (because he would not separate the two). It is a language of war, of throwing, projecting, sending projectiles, missiles on to the surface as aggressions. He is at war with the culture, with all its affiliations, with the family, with a number of institutions. Perhaps we will see projected one of these drawings in which the drawing is a spell against a certain adversary who embodies the culture of the museum, the visual art mausoleum where one archives and keeps the dead bodies of works of art.

The subjectile...I don't know if everybody here is familiar with this concept, it is a non-common word, even in French. It is an old technical word meaning what is put under the drawing or the painting, the canvas or "support," as you call it. This is a word that Artaud uses three times in his writings, saying that he has this drive to attack the subjectile, to mistreat, to rape and be violent with the subjectile which is a substance lying under his body, under the *couche*. Many acts of sexual violence, rapes and so on, are at work

in the subjectile. So he tries to project projectiles against the subjectile, and sometime he makes actual holes in the support. Now, you said that this reminds you of the symbolic in Lacan?

TS: It reminds me of his concept of "the real," that is to say, the transition between the unconscious and the symbolic, in Lacan's scheme. The interesting thing here is that to use the word "subjectile" might be to simply offer a mere description, or it could be insightful to use an ordinary word like "support" or "base" (of a work of art) as a pointer to a much more undecidable and difference-producing domain, if you like. I am looking for a concept that will do that kind of work without flattening out what is going on in the processes of creativity, the plays between necessity and choice in artmaking.

JD: It would certainly help to have such a concept. I try in the text on Artaud to analyse all the ambiguities and undecidabilities of the concept of the word "subjectile." But if I had to refer to Lacan I would rather look on the side of what he calls "the impossible," the real as the impossible rather than the symbolic, because what Artaud tries to do in many drawings, paintings and inscribed discourse within the painting is precisely to destroy—I wouldn't say deconstruct—the symbolic. That is, the father, mother, the family order, not only his own family order but also the Christian family order. This is a recurrent theme in his texts and his drawings. The inclusion of words in his drawings shows precisely his having been stolen, his body having been stolen by God, by the Christian God, by the father-mother, and so on and so forth. He struggles always to reconstitute his own intact body. That is why my reading of Artaud is full of admiration and sympathy but sometimes also suspicious about the reconstitution of the metaphysical desire for the proper body, the body proper—intact, pure and without organs, the organless body, an undifferentiated body—which would resist appropriation, at the very

moment of his birth, by Christian culture, by the family and all the other institutions.

TS: Perhaps we could give some visual sense to what we have been talking about by looking at a few images, beginning with Artaud's *Self-portrait with dagger* of March 1947?[34]

JD: You can see how his drawings are full of sentences and language fragments, not only intelligible sentences in French that you could read but sometimes what we call glossolalia, pure phonemes for names which are incompatible with French grammar. As some of you may know, he was constantly trying to charge this glossolalia with sounds, unintelligible sounds—he was speaking in tongue, so to speak. What I was interested to do in this book was to analyse the close and very, very refined relationship between the drawing itself and the syllables, the phonemes and the vowels around them. This deserves kind of close analysis that we cannot do here.

TS: The next image, from May 1939, is an example of the kind of missive you mentioned earlier. It is *Sort*, which translates as 'fate' or 'spell', a magical spell...[35]

JD: At the end of his life, when he was in a psychiatric institution, he sent a lot of such spells to enemies, to people who he supposed were determined to threaten him or persecute him. So he would burn the subjectile with a cigarette or a match. Many of these messages were personal, but some involved social scenarios. He even sent such spells to Hitler, which means that he wanted his works of art to be efficient, to change the world, not as representations but as projectiles that you send by the mail, that you send to the addressee in order to wound or to save or warn about some danger. He wanted to change the world by drawing, inscribing words, burning and sending the work of art out to actual people and places, away from any museum or archive. It had to do the job, to be performative,

singularly and immediately. It had a singular addressee, and it should change the situation at the moment it was signed and sent.

TS: The next one relates to the theory of theatre for which Artaud is famous. In *Theatre of Cruelty*, a drawing of March 1946, you see a self- portrait in a coffin...[36]

JD: In these drawings there are a number of coffins and weapons, cannons, phallic forms, that is, pointed weapons. What he called the Theatre of Cruelty was something he elaborated as a theory before the Second World War, whereas these drawings were produced after that time. In the 1920s and 1930s he developed the concept of the Theatre of Cruelty, in which one had to break with the tradition of the theatre of representation in which the text or the spoken language would dominate the stage. As you know, he was an actor and a playwright, a man of the theatre, so there was something consistent between his idea of the theatre in the western culture and his roles in these drawings.

TS: This drawing dates from February 1946 and is *The Bouillabaisse of forms within the Tower of Babel*. Some of the shapes are quite strange: on the upper left there is a kind of film projector, and below it a camera-creature.[37]

JD: What is striking first of all is the difference between this epoch, the drawings of this moment after 1946, and what he was drawing and painting in the 1920s. He also wrote a lot of scholarly, informed articles about the salons, the exhibitions, in the 1920s. So the apparent awkwardness of these drawings is not simply an accident, as if suddenly he had lost the mastery of his art. No, he also had an intentional theory or doctrine about this *maladresse*. He wanted to be awkward, to be—how you say—"maladroit," because he was at the time considering that the teaching of the art of drawing, the discipline, was impregnated by the culture he was rejecting.

So he wanted to calculate the transgression of the norms of good drawing. When he uses the word *"maladresse,"* which comes back again and again, you have of course "mal-address" in the sense of the wrong address, maladroitness in the sense of awkwardness, and the apparent misdirection of his own drawings, their projection as a counter-attack against what he called God's sexual *maladresse*...everything in his own mythological history followed from God's sexual awkwardness.

TS: We now have a look at a drawing, *The Sexual Awkwardness of God*, from February 1946.[38]

JD: To Artaud, it was because of these sexual misdeeds of God that everything bad followed: that is, Christianity, the mother-father, the trinity, the execration of the mother-father, his own body being stolen at his birth, and a lot of wicked powers hounding him behind his back. He felt constantly threatened and attacked by these evil or wicked forces, which he called succubae, and which came from God's sexual awkwardness.

TS: There is a drawing of April 1946 entitled *The Abomination or the execration of the father-mother*, which is now on view.[39] In February 1947 he wrote the following: "The figures on the inert page said nothing under my hand. They offered themselves to me like millstones which would not inspire the drawing, and which I could not probe, cut, scrape, file, sew, unsew, shred, slash and stitch without the subjectile ever complaining through father or mother." [40] This is a remark that confirms in Artaud's words the kind of commentary you have been making.

JD: May I say something in quick parenthesis. What is ironic in this violent and systematic attack against the family, and the holy family, is that after his death when Artaud left all his drawings and manuscripts to Paule Thévenin—who wrote this book with me and who

has edited twenty-five volumes of his unpublished works—it was his nephew in his own family who sued Paule Thévenin for having published all his texts and tried to prohibit the publication of other texts by Artaud, as well as paintings and drawings by him. This is why we could not have it translated until recently, and why there are no reproductions of the drawings in the English edition. The nephew wanted to reappropriate the property of his uncle—that is one irony of family heritage. Fortunately, three months ago he lost his case and I hope now we will be able to publish the book with the illustrations.

TS: We spoke privately about whether the kind of discussion that we are having now about Artaud could have been applied to the works of other artists, for example, Jackson Pollock. An image of his *Blue Poles* of 1952—a famous painting that hangs in our National Gallery in Canberra—is being projected at the moment. One way in which some of us are thinking about this work, about this kind of work, is that the subjectile might be relevant to understanding it more fully. To feel threatened by the subjectile, to fall subject to it, to attack it by throwing things at it, to botch it—perhaps Pollock did similar things to Artaud. To my mind, in these works, and perhaps in a few others, at a level or moment before figuration, before style is achieved, there is an exposing of the subjectile. Curiously, it is a subjectile that seems already worked over in a number of ways. I don't simply mean that the painting begins in a physical sense as a piece of canvas on the floor, but rather that for the artist it has already begun as a surface which is both actual *and* imagined, that is, two surfaces, from the realisation that these both match but also do not match. So painting in this case becomes a kind of surfacing, a practice of generating surface(s), as it were, from between these two, and from within this double sense of surface. As you know, many of Pollock's paintings done around this period are very large works. In that they differ greatly from Artaud's sketches. But, some of them, probably most, have figura-

tive under-drawings which one might connect with the kind of
drawing which Artaud did in that they are not just psychological
but psychoanalytic—literally, in the sense that they were precipitat-
ed in part by analysis. Yet the specifics are also very different, as
one would expect. Structurally, the two artists have in common a
propensity to overlay and superimpose structures over other ones.
So, in the case of *Blue Poles*, the under-drawing is overlaid by vari-
ous levels of dripped paint skeins, and then that surface is both bro-
ken and reasserted with the "poles." These were made by him tak-
ing up a long stake, a stick doused in blue paint, which he then
banged onto the painting at various points, botching it in one sense,
yet the "poles" have also the grace of a dancing figure, or perhaps a
set of figures. Overall, you might say that the already equivocal
subjectile of the canvas, real and imagined, is doubled—in fact,
multiplied—by another set of surfaces which work as screens.⁴¹

JD: I feel unprepared to say something about this work, but let me
try nevertheless. I am wondering what Artaud would think. I have
read the text he wrote on painting when he was young: he was of
course against academic painting, but he also hated non-figurative
and abstract painting, especially that based on exact drawing.⁴² He
was after all, in a certain way, a figurative painter—he had to strug-
gle with figures, with figuration, as you say. One question that we
could ask is this: is it possible to make a subjectile as such mani-
fest? Can one paint or make the subjectile appear as such, that is,
uncovered by the layers of figures and paint and so forth? No doubt
Pollock was also projecting with a gesture of his own body; we see
him in many photographs in movement, projecting, painting onto
the subjectile. Was he doing so in order to provoke the subject out,
to induce it to appear as such? Or did he try to hide the subjectile,
or to do something else altogether? You see, if every work is a
unique event it means, it might mean, that each time, for each work
of art, there is another *mise-en-scène*, another stage, another plot in
the subjectile. So this work is undergoing a certain plot in which the

subjectile is a character, so to speak, that is, the painter doing something to the subjectile—what exactly, I can't tell. I admire Pollock but I am totally unable to carry this analysis further.

Specters of Media

Terry Smith:

My colleague Alan Cholodenko has written a question on what we are calling here the visual/textural culture of mass media, of news, information transfer, advertising, film, television, the internet, and so on. It goes as follows:

> In *Specters of Marx*, a book of 1994, you say: "As for the logic of spectrality, inseparable from the idea of the idea ... inseparable from the very motif (let us not say the "idea") of deconstruction, it is at work, most often explicitly, in all the essays published over the past twenty years, especially in *Of Spirit*." [43] In the wake of that statement a series of questions propose themselves. Are the mass media—that is to say advertising, film, television, the internet—our contemporary forms of the specter? What is at stake in the specter for art, for the image and the mass media: is it the work of endless mourning over the ruin of/at the origin of representation, as you suggest in *Memoirs of the Blind*? Is the writer not likewise implicated in the specter, is the writer never not a ghostwriter?

JD: It is true that I realised retrospectively how everything I wrote for a long time was haunted, so to speak, by a number of specters named by their names, long before I wrote *Specters of Marx*. There

were specters everywhere—in *The Post Card*, for example.[44] Of course, the concept of the spectral has a deconstructive dimension because it has much in common with the concepts of trace, of writing and *différance*, and a number of other undeconstructible motifs. The spectral is neither alive nor dead, neither present nor absent, so in a certain way every trace is spectral. We always have to do with spectrality, not simply when we experience ghosts coming back or when we have to deal with virtual images. Even here, there is some spectrality, when I touch something. Now, of course, once you have determined this general spectrality, then within this frame you have to further determine different kinds of spectral dimensions. One of my concerns, not only in *Specters of Marx*, but long before then, had to do with the work of mourning. In *Memoires: For Paul de Man*, I tried to show that what one calls in psychoanalysis "the work of mourning" is not one experience among others.[45] Every work is a work of mourning, that is, a way of leaving a trace, of abandoning what we are saying and doing and leaving something. We are constantly mourning and experiencing mourning and, to that extent, there is spectrality everywhere. Then we have to interpret this work of mourning everywhere. In *Specters of Marx* I try to understand what mourning might mean politically, that is, to articulate a historical, political interpretation of the end of the communist regimes or the death of Marx, as they say. What is the work of mourning at work in world capitalism? How to decipher all the symptoms of this ghost is what I am trying to do in *Specters of Marx*.

Now, how are we to apply these thoughts to the media? There is no doubt that the extraordinary technological development of the media has to do with the unprecedented, unheard of possibilities of spectrality, and that teletechnology is a way of producing, handling, organising, making profit out of some spectrality. The structure of television, the structure of computerisation, has everything to do with spectrality. This has deeply transformed the public space, that is, the political space, not only nationally but also through what is called globalisation, *mondialisation*. For that rea-

son, of course, the power and thus the responsibilities of the media are enormous. There is nothing in the world, and certainly no political or economic power, which could avoid being dependent on the media. This is trivially obvious.

TS: That is my cue to ask you about what you are quoted as saying in *The Australian* newspaper on Tuesday, two days ago. I believe that you were addressing the assembled news media at Monash University and apparently you said to them that "the media is the main political problem facing the world today." And then went on to say that "One of the main political duties is to think and transform the ethics of the media."[46] Would you please elaborate on that statement, or correct it if it itself has been politicised?

JD: It is true, what I said was true…it is not the most original thing I have said, but it has to be repeated all the time. I ask the ethical question: what should be our duty in these circumstances? It is, first of all, to develop a critical culture of the spectrality of the media. For instance, we must suspect what the media wants us to rely on; we know how they can interpret, filter, sophisticate, the so-called live reports. They pretend that they are showing us the thing itself, for example, the attacks during the Gulf War. We all see, so we have to know and to teach the way the media fabricate artificially their objects, their information, and so on and so forth. This teaching is not only our responsibility outside of the media, it is also the responsibility of people in the media to cultivate this critique, to teach technically what happens in the media, and also to resist the concentration of the international corporations which more and more control this power. So, it is a political and an economic struggle, to do whatever we can in order to complicate, to introduce heterogeneity within this more and more hegemonic structure, so that there is not one main media, something like CNN, governing the flow of information all over the world. I think that critical cultures are developing now not only outside of the media but there are with-

in the profession of journalism people who try to be vigilant and resist the power of these corporations. The responsibility is very, very difficult and the strategy is very difficult...to introduce some heterogeneity without disseminating or imperiling the media's universal reach or scope. We have to have both, because the media are also a democratic power, a key instrument of democratisation.

During the last decades the media have crossed borders, they have divulged models of other societies and so on—this has been essential to democratisation. So there is good in the media and we should not ignore this. I am not an enemy of the media, I never say that the media is something bad and that we should withdraw from it. No, no. It is our duty as citizens of the world, as citizens of the nation and citizens of the world, to cooperate with the people in the media who are ready to do critical work. Indeed, we should work together as people who are more than citizens, because I would advocate something that would go beyond cosmopolitanism as universal citizenship. In *Specters of Marx* I speak of a "new international," one which would go beyond citizenship, beyond belonging to a nation state.[47] Between these people who are more than citizens some allegiances should be possible or looked for in order to develop this critical culture about the media with all the double binds and the contradictions that it involves.

Of course, people like us, that is people in the academy who try and write complicated things, when we speak of duty, it is because we experience but a small part of the problem. As soon as we give an interview or speak from a microphone, it is a catastrophe. Everybody suddenly thinks I am over-simplifying. My complaint is that that each time I do this I realise that I should not have done so because what I said is immediately over-simplified and distorted.

Let me tell an Australian anecdote. When I was in Melbourne, I accepted to give interviews. Normally, I am reluctant to do this, not because of some elite aristocratic feeling but because I am very bad at it. I know from my experience what follows. Nevertheless, I had to accept because of the hospitality of my hosts.

So there was an interview with television, written press, radio and all the rest. A number of questions were asked and answered more or less, but the only thing that was kept and published was a minimal sentence I had uttered on the Aborigines. I had given a lecture on forgiveness, "On Forgiving the Unforgivable," and someone asked me: "Do you think that we should make apologies, that the Government should apologise to the Aborigines?"[48] So I said, using the well-known diplomatic stereotype, "Well, you know, I'm a stranger here, that is a problem for Australians, for the Australian government to take on its own responsibility. I am not here to give advice to you or the Australian government." I went on like this for a long while, but they insisted, so I replied. "If you insist I will say yes, the government should apologise on behalf of the Australian people…it is not a matter of forgiveness, we cannot ask for forgiveness from or for people who are dead or not here, but we know that an apology is also a promise for the future, a promise to change the situation. So, to that extent perhaps, it might be better if the government did apologise, but that is up to you." Then the next day in the national newspaper, next to a huge picture of me, was the headline "French philosopher urges our government to apologise to Aborigines." I find this terrible, but I am not totally unhappy that it happened. [Applause]

TS: We are coming to a close so I just want to give Professor Derrida a chance if he wishes to comment further on anything we have covered, anything left in the darkness of Plato's cave…

JD: What leaves me anxious is that, because of the speed and the scenario, I had to oversimplify a lot of things that I would have liked to improve on and to refine. So my only prayer would be that you just forget what I said, and try if you are interested to look at the works by Artaud and Adami, and perhaps the books we have mentioned. What I write is, in general, not as bad as what I say.

TS: Please join me in thanking all of those who made tonight's event possible, and particularly Professor Derrida for his work. [prolonged applause]

Notes

1. This critique is advanced in, for example, the essay "Structure, Sign and Play in the Discourse of the Human Sciences," in Jacques Derrida, *Writing and Difference*, London: Routledge & Kegan Paul, 1978, 278-293; and in *Of Grammatology*, trans. Gayatri Spivak, Baltimore: The Johns Hopkins University Press, 1974.

2. The remark "il n'y a pas de hors-texte" occurs in the chapter "…That Dangerous Supplement…" (See *Of Grammatology* p.158), after a long passage in which Derrida speculates about the extraordinary variety of ways in which the logic of supplementarity occurs in Jean-Jacques Rousseau's books and essays (written language as supplement to the spoken word, masturbation as a supplement to conjugal sexuality, etc). This disruptive, unintended, uncontrollable recurrence indicates that "the writer always writes *in* a language and *in* a logic whose proper system, logic and life his discourse by definition cannot dominate absolutely." A "critical reading" of, say, Rousseau's writings would articulate an account of this interplay of control/lack of control (it should, in Derrida's words, "produce the signifying structure" at work in the writing). A "doubling commentary," one which sets out all the circumstances of the writing, is essential but, in Derrida's view, it is finally a repeat of the first text. Similarly, to allocate the entire meaning of texts to something other than their own struggle with the constraints and possibilities of the language in which they were written is a mistake. There is no "referent," separate from the process of the writing, which will provide the key to interpretation. Nor is something like "the real," "the artist," "the will of God," or "the logic of history" the ultimate arbiter (Derrida calls these "transcendental signifiers"). Literally, the remark "il n'y a pas de hors-texte" means "there is no outside-text." In context, we can see that Derrida intended to offer, as a "principle" of what it is to read texts critically, the need to recognise that there is no other, non-textual domain which harbours secret answers to the problems of reading. He was not making an epistemological statement.

3. Most concisely, in the essay "Mallarmé," in Jacques Derrida, *Acts of Literature*, ed. Derek Attridge, New York: Routledge, 1992, 110-126, and most thoroughly in "The Double Session," in Jacques Derrida,

Dissemination, Chicago: University of Chicago Press, 1981, 175-285. These essays are also a good introduction to the concept of *espacement* that occurs later in the discussion.

4. Jacques Derrida, *Memoirs of the Blind: The Self-Portrait and Other Ruins*, trans. Pascale-Anne Brault and Michael Nass, Chicago: University of Chicago Press, 1993.

5. "Pure opticality," a core value for modernist formalism in the visual arts, is a term used by Clement Greenberg in his essay "Modernist Painting," Voice of America radio lecture 1961, *Arts Yearbook*, 4, 1961, 101-108. Key texts on materiality in Minimalism include Donald Judd, "Specific Objects," *Arts Yearbook*, 8, 1965, reprinted in *Judd: Complete Writings*, Halifax, N.S.: Nova Scotia College of Art and Design, 1975, and Robert Morris, "Notes on Sculpture, Parts One and Two," in G. Battcock, ed., *Minimal Art*, New York: Dutton, 1968. A compendium of conceptualist practices may be found in Lucy Lippard, *Six years: The Dematerialization of the Art Object from 1966 to 1972*, New York: Praeger, 1973.

6. See, for example, Plato, *The Republic*, trans. F.M. Cornford, Oxford: Clarendon Press, 1941, Book VI-VII. Derrida discusses these Platonic figures and metaphors in "White Mythology," in *Margins of Philosophy*, trans. Alan Bass, Chicago: University of Chicago Press, 1982, and in "Plato's Pharmacy," in *Dissemination*, trans. Barbara Johnson, Chicago: University of Chicago Press, 1981.

7. Maurice Merleau-Ponty, *The Visible and the Invisible*, trans. Alphonso Lingis, Evanston: Northwestern University Press, 1968.

8. Derrida, *Memoirs of the Blind*, 52.

9. Merleau-Ponty, *The Visible and the Invisible*, 229.

10. Ibid., 247.

11. Ibid., 248.

12. Martin Heidegger, *Being and Time*, Tübingen: F. Niemayer, 1927, p.358.

13. Martin Jay, *Downcast Eyes: The Denigration of Vision in 20th Century French Thought*, Berkeley: University of California Press, 1993.

14. Edmund Husserl, *Ideas Pertaining to a Pure Phenomenology and to a Phenomenological Philosophy.* Book II, *Phenomenological Investigations Concerning Constitution*, trans. F. Kersten, The Hague: Nijhoff, 1982. See Jacques Derrida, *Edmund Husserl's Origin of Geometry*, trans. John Leavey, Boulder: John Hays, 1978.

15. Since published: Jacques Derrida, *Le Toucher: Jean-Luc Nancy*, Paris: Galilée, 2000.

16. For example: "A draftsman cannot but be attentive to the finger and the

eye, especially to anything that *touches* upon the eye, to anything that lays a finger on it in order to let it finally see or let it be seen. Jesus sometimes heals the blind simply by touching, as if it were enough for him to draw the outlines of the eyelids in space in order to restore sight." *Memoirs of the Blind*, 6.

17. John Joseph Wardell Power was a medical graduate of the University of Sydney who became a neo-Cubist painter in Bournemouth and Paris during the 1920s and 1930s. He died in 1946 leaving an endowment that charged the University to "bring to the people of Australia the latest ideas and theories...concerning contemporary art." The Power Institute was created in 1967 to fulfill this objective.

18. The word "khôra" is a common Greek noun for an area or place. Derrida discusses Plato's use of this word in the *Timaeus* to refer to something that is not a thing at all but a kind of receptacle in which existent things are. "Khôra" is neither intelligible being nor sensible becoming but something "in between" both of these. See Jacques Derrida, *Khôra*, Paris: Galilée, 1993; in English in *On the Name*, ed. Thomas Dutoit, Stanford: Stanford University Press, 1995.

19. The series of exhibitions was entitled *Parti Pris*, that is, "taking sides." It was devised by two curators in the Department of Drawings at the Louvre, and entailed following this rule: "to give the choice of a discourse and of the drawings that would justify it—drawings taken for the most part from the Louvre's collections—to personalities known for their critical abilities, however diverse they may be" (cited in *Memoirs of the Blind*, vii.). Subsequent curators included the filmmaker Peter Greenaway, whose 1992 exhibition was entitled *The Sounds of Clouds: Flying Out of This World*.

20. Derrida cites some notes he took on wakening from this dream; see *Memoirs of the Blind*, 16.

21. Illustrated, *Memoirs of the Blind*, fig. 1, page 7. Early in the dialogue which constitutes the main text Derrida puts forward two hypotheses, the first relating to the act of drawing, the second to the inevitability of the self-portrait: "the drawing is blind, if not the draftsman or draftswoman," and "a drawing of the *blind* is a drawing *of* the blind...Every time a draftsman lets himself be fascinated by the blind, every time he makes the blind a theme of his drawing, he projects, dreams or hallucinates a figure of a draftsman, or sometimes, more precisely, some draftswoman" ibid., 2. Later in his life Henri Matisse would often describe his moment of intense concentration prior to executing a rapid sketch as "drawing with my eyes shut." See anecdotal evidence in Janet Flanner, *Men and Monuments*,

Profiles of Picasso, Matisse, Braque and Malraux, New York: Da Capo,
1957, 114.
22. "The first would be the invisible condition of the possibility of drawing,
draw*ing* itself, the drawing of drawing. It would never be thematic. It could
not be posited or taken as the representational *object* of a drawing. The sec-
ond, then, the sacrificial event, that which comes to or meets the eyes, the
narrative, spectacle or representation of the blind, would, in becoming the
theme of the first, reflect, so to speak, this impossibility." *Memoirs of the
Blind*, 41.
23. On Fantin-Latour's self-portraits, see *Memoirs of the Blind*, 57 and 62,
on the self-portrait as ruin, see 68.
24. Illustrated fig. 8, *Memoirs of the Blind*; discussed in detail in relation to
Plato's cave allegory and to Descartes, 13-15.
25. Illustrated fig. 10, *Memoirs of the Blind*; the tradition of blind writers
discussed in detail, 35-43.
26. Illustrated fig. 32, *Memoirs of the Blind*; on voyeurism as mourning for
love as ruin, see 68, on the never-ending ruse of narcissism, see 70.
27. Derrida, *Memoirs of the Blind*, 43.
28. See Nicholas Mirzoeff, *Silent Poetry: Deafness, Sign Language and
Visual Culture in Modern France*, Princeton: Princeton University Press,
1995.
29. Illustrated fig. 17, *Memoirs of the Blind*; discussion, 44.
30. Illustrated fig. 39, *Memoirs of the Blind*; the sequence of closed-eye
self-portraits culminates in Gustave Courbet's *Self-Portrait (The Wounded
Man)*, 1854, Musée d'Orsay, figs. 39-43.
31. Jacques Derrida, *The Truth in Painting*, trans. Geoff Bennington and
Ian McLeod, Chicago: University of Chicago Press, 1987. Chapter 2 "+R
(Into the Bargain)" explores a set of drawings by Adami, two of which
were based on Derrida's 1974 book *Glas* (Lincoln: University of Nebraska
Press, 1976). Other parts of the book deal with Cézanne's remark to Emile
Bernard from which its title is drawn, the work of French conceptualist
Gérard Titus-Carmel, and the commentaries by philosopher Martin
Heidegger and art historian Meyer Schapiro on Van Gogh's painting *Old
Shoes with Laces*.
32. Paule Thévenin and Jacques Derrida, *Antonin Artaud, Dessins et por-
traits*, Paris: Gallimard, 1986. This text includes illustrations and extensive
notes on them. Jacques Derrida and Paule Thévenin, *The Secret Art of
Antonin Artaud*, trans. Mary Ann Caws, Cambridge, Mass: MIT Press,
1998. This text does not include illustrations of Artaud's work, as permis-
sion to reproduce them was withheld (see Derrida's comment in the discus-

sion).

33. See Jacques Derrida, *"Différence"* in *Margins of Philosophy*; *Of Grammatology*. pp.101-140; *Writing and Difference*, passim; and in the interviews with Henri Ronse and Julia Kristeva in Jacques Derrida, *Positions*, trans. Alan Bass, Chicago: University of Chicago Press, 1981, 8-10 and 24-30.

34. Illustrated fig.8, Thévenin and Derrida, *Antonin Artaud, Dessins et portraits*.

35. A number of these missives are illustrated, ibid., figs. 32-41.

36. Illustrated ibid., fig. 62. For further commentary see "The Theatre of Cruelty and the Closure of Representation," in Jacques Derrida, *Writing and Difference*, 232-250. And see also various texts in Edward Sheer, ed., *100 Years of Cruelty: Essays on Artaud*, Sydney: Power Publications, 2000, especially Samuel Weber, "The Greatest Thing of All: the virtuality of theatre," and Edward Sheer "Sketches of the *jet*: Artaud's abreactions of the system of the Fine Arts."

37. Illustrated fig.59, Thévenin and Derrida, *Antonin Artaud, Dessins et portraits*. For commentary on this drawing see *The Secret Art of Antonin Artaud*, 83, 108-109.

38. Illustrated fig 60, Thévenin and Derrida, *Antonin Artaud, Dessins et portraits*.

39. Illustrated fig. 67, Thévenin and Derrida, *Antonin Artaud, Dessins et portraits*. For commentary on this drawing see *The Secret Art of Antonin Artaud*, 83, 132-133.

40. Cited in *The Secret Art of Antonin Artaud*, 136-136; for commentary see ibid. 137-143.

41. On Pollock see Kirk Varnedoe and Pepe Karmel, *Jackson Pollock*, New York: Museum of Modern Art, New York, 1998. On his experience of psychoanalysis see C.L. Wysupth, *Jackson Pollock: Psychoanalytical Drawings*, New York: Horizon, 1970, and Claude Cernuschi, *Jackson Pollock, Meaning and Significance*, New York: HarperCollins, 1992. On surfaces and screens in this context see Terry Smith ed., *Impossible Presence: Surface and Screen in the Photogenic Era*, Sydney: Power Publications; Chicago: University of Chicago Press, 2001, and Samuel Weber and Terry Smith, *The Theatre of the Image: Kierkegaard, Artaud, Pollock*, Minneapolis: University of Minnesota Press, forthcoming.

42. Comments on Picasso in 1924 as lacking in "expression," cited in *The Secret Art of Antonin Artaud*, 102, and on cubism in 1921 as inclining to a petrifying uniformity, ibid., 153, n. 62.

43. Derrida, *Specters of Marx, The State of the Debt, the Work of Mourning*

and the New International, New York: Routledge, 1994, 178, n3.

44. Derrida, *The Post Card, From Socrates to Freud and Beyond,* trans. Alan Bass, Chicago: University of Chicago Press, 1987.

45. Derrida, *Memoires: for Paul de Man,* trans. Cecile Lindsay, Jonathon Culler, Eduardo Cadava, Peggy Kamuf, New York, Columbia University Press, 1986.

46. *The Australian,* August 10, 1999.

47. Derrida, *Specters of Marx,* 84 ff.

48. A major debate rages within the Australian polity over the extent to which non-indigenous Australians owe a debt of apology to indigenous Australians, the Aborigines, for wrongs visited upon them since Settlement in 1788. As a crucial element in the current, official process of reconciliation between the races, Aboriginal representatives have asked the Australian Government for a formal expression of sorrow for past injustices, and for the opportunity to forgive them. In particular, an apology is sought for governmental policies which, in the past, led to the deaths of indigenous peoples and to the systematic breaking-up of Aboriginal families. Since its election in 1996, the current Liberal Party conservative government has consistently refused to utter the key word, "sorry," on the grounds that it does not reflect the opinion of all Australians, and that it would lay the state open to claims for compensation.

II

AFFIRMATIVE DECONSTRUCTION, Seymour Center, University of Sydney, August 13, 1999

Jacques Derrida in discussion with

Genevieve Lloyd, David Wills,

Paul Patton and Penelope Deutscher

1. Time and Memory, Messianicity
and the Name of God

2. Affirmative Deconstruction,
Inheritance, Technology

3. Justice, Colonialism, Translation

4. Hospitality, Perfectibility,
Responsibility

5. Open Discussion

Time and Memory, Messianicity, the Name of God

Genevieve Lloyd:

In these few brief background remarks to introduce my questions to Professor Derrida, I want to emphasise an aspect of his work that is perhaps not so well-known. Although it is constantly—especially in its later phases—pressing at engaging issues of our own present, it is an approach to philosophy that is thoroughly grounded in the history of philosophy. Derrida is always going back to texts of the past, providing ever-fresh readings of them. Moreover, he reads texts of the past of philosophy as a way of engaging with the present, as a way of facing the future. So although the work of Derrida is often, and I think often misleadingly, associated with a drastic, a very radical break with the past, including the past of philosophy, there is an abiding closeness with past philosophical texts.

I think that aspect of Derrida's work—the manner in which the past, the present and the future come together in his philosophical practice—reflects a fascinating strand throughout the whole of his work, which is an abiding interest in the philosophy of time, and especially with how we should think the relations between present, past and future. This is very strong, of course, in his early writings.

The strategies of deconstructive reading associated with the notion of *différance* are well known, even if often not always well understood. But what is less often remarked upon is that they express very subtle critiques of traditional philosophical ways of thinking of time, and especially of the so-called 'primacy of the present'. Many of us I am sure are familiar with that as part of the critique of the 'metaphysics of presence' with which Derrida's work has been so much associated.

It is this thread of the philosophy of time that I want to bring out in leading into the questions that I want to put to him. There is a challenge to very old ways of thinking of time that are still very familiar to us, very much part of *our* ways of thinking of time, where the present is the fundamental thing. St Augustine put it perhaps most eloquently when he said that wherever the past and the future are, they are there not as past or as future, but as present. So there is a 'past present' and a 'future present' and along with that a way of thinking of time as a succession of 'nows', a succession of presents. This is challenged in Derrida's early work, but I think the challenge is still there, and the constant rethinking of how we should think the relations between present, past and future persists into the later writings. It is there as a crucial element in the very moving *Memoirs for Paul de Man*, where themes associated with bereaved memory are interwoven with reflections on friendship and responsibility, and with reflections on how we can and cannot answer for another.[1] The very idea of 'impossible mourning', about which I will say more in a moment, depends crucially on thinking through these relations between present, past and future. But I think it is there too in some of the much later writings. Some of Derrida's most recent writings talk of a 'messianic' structure of consciousness, which involves thinking this time of the future not so much as something which is a future present, a to-be-expected actual event in the future, but as a structure of consciousness, a future which cannot be reduced to a future present.

Here in our own Australian present, the issue of how to think the relations between time, mourning, grief and responsibility is a very live one. Non-indigenous Australians are having to rethink the received history and memories of the treatment of Australia's indigenous peoples, and to respond to demands that they take responsibility for a past in which they did not themselves act, a past in which they may well feel they had no real presence. Indigenous Australians are being asked to be reconciled to an oppressive past, which they are expected to think of as entirely disconnected from their present and their future. Again, we encounter here that way of thinking of the past as something 'disconnected' from present and future.

Well, it would be quite inappropriate for us to ask of Professor Derrida that he should take on the task of applying his philosophy in this contemporary Australian present. But I wish to have those concerns in the background of our discussion, as I invite him now to reflect for us on how he himself sees the connections between time and responsibility in his work, and on how his philosophical understanding of the relations between the present, the past and the future bears on his ways of practicing philosophy.

My questions concern the way in which themes of time, possibility and impossibility come together in Derrida's later writings. First, the concept of 'impossible mourning', which he explores, especially in the *Memoirs for Paul de Man*, but also later, in such works as *Politics of Friendship*.[2] The 'possibility of the impossible' which, he says, commands the 'whole rhetoric of mourning' and describes the essence of memory. It is a way of thinking of bereaved memory, I think, which can challenge talk— which is very common but too easy—of a supposed 'resolution' of grief, of mourning, whether at an individual or at a collective and social level. It is a challenge to the thought of grief as something which is eventually—ideally, sooner rather than later—to be left behind, in a past which no longer disturbs the present. But Derrida's analysis of 'impossible mourning' reaches beyond the

understanding of grief. It is one of those self-limiting concepts which he often talks of in his later writings, where thought pushes against its own limits, turning into its opposite. Hence, the 'impossibility'. We want to interiorise the memory of the Other, to bear him or her within us. Yet they remain, as they must, outside us, in death, in an irrevocable absence. In the contradictory shifts of bereaved memory, as Derrida puts it, success fails and failure succeeds. If mourning succeeds in interiorising the dead Other, then it must fail in the task of respecting their otherness. And in that way the possibility of impossible mourning emerges as part of the very structure of friendship, even before actual death intervenes. So the 'impossibility' that is at stake here comes not from some finite limitation of memory, it's there in the very structure of our relations to other selves, it's there just as much in the living present as it is in the as yet future mourning or grief.

This analysis of the way present, past and future come together in what Derrida calls 'impossible mourning' may, I think, have far reaching consequences not only for how we understand grief, but more broadly for how we think of memory itself, and especially of the social dimensions of memory. So my first question is: What do the 'impossibilities' in bereaved memory show us about how to think of memory itself—about how to think of our past? And then my second question: What of how we are to think of our future? In some of your later writings you talk of a 'messianic' structure of consciousness—of a way of thinking of the future which does not translate into thoughts of a future present, which will one day actually arrive—but into thoughts of a future which is always 'to come'. Thus construed, the anticipation of a hoped-for future is not a facile optimism. The 'to come' here is not a determinate event, the expectation of which might show us how to live in the present. It is not a utopian 'vision' of the future, it doesn't unfold in the determinate expectation of an event that we await. Uncertainty about the future is often thought of as one of the 'problems' of our period of history—something to be remedied, perhaps

by recovering some of the basic certainties of the past. So my second question is: Might an understanding of what you describe as the 'messianic' structure of consciousness, perhaps open up an alternative approach to the loss of old certainties? Can reflection on the messianic structure of consciousness help us live more constructively with uncertainty?

And my third question: I would also like to ask about the theme of impossibility again, this time in relation to some of your recurring reflections about God, and more specifically, if indeed this can be regarded as *more* specific, in this context, about the name of God. I'm thinking here especially of an essay called *Sauf le Nom*—'except the name', 'nothing but the name', but also 'safe, the name', an essay reflecting on the name of God which issued from a symposium on negative theology.[3] There you reflect on a kind of religious consciousness which can co-exist with—nonetheless—honestly describing oneself as an atheist. It's another example of the 'possibility of the impossible', that we've made the central theme of this afternoon's discussion, one that you mention there along with the gift, the secret, testimony, friendship and, as you suggest in passing, also perhaps death. (The desert beyond God? Going where one cannot go?) You have said in that essay that atheism testifies to the desire of God. My third question then is: How would you articulate this desire of God which can co-exist with the lack of belief in any determinate existing God? And how does it bear on thinking that final possibility of the impossible—namely death?

Derrida:

First of all I want to thank you again, all of you, the audience, and my friends and colleagues here at the same table. I'm very very grateful, and facing again a very difficult task, but I'll try not to simply respond, that is to provide some responses, some solutions, but to, let us say, insist within the difficulty. I want to thank you [Professor Lloyd] for everything you said which was really remarkably thought out, formalised and lucidly phrased. I've nothing to

object to in anything you said, but I'll try to simply *remain* within the space that you so powerfully described, and to explain why I cannot do anything else than remain in a certain way within this aporia, since aporia is the common theme of this discussion.

First of all, I totally agree with you that in fact my interest in the history of philosophy, which has been a constant and loving one, and as faithful as possible, has nothing to do with breaking with the past. There is no such break in my way of relating to the history of philosophy, even with the philosophers, the corpuses that I read in the most, let's say, deconstructive fashion. On the contrary, it is an act of love, an act of faithfulness. There is no break there, but an act of inheriting, a way of inheriting the past. And of course this implies what you call a philosophy of time, and a way of struggling with this primacy of the present.

Of course, this was nothing new when I started writing and teaching. There was, on the one hand, Husserl's insistence on what is for him the *absolute form*, what he calls the *Ur-*, the originary form, the *Ur-form* of the transcendental experience, that is the *lebendige Gegenwart*, the living present. For Husserl, there is no possibility for any experience to be...let's say...other than present. Even the past and the future are modifications of the presence of the present, as life, because he insists on the questions of the living present. So that, since I started studying Husserl, that was my first difficulty. I was also reading Heidegger who, as you know, started with a deconstructive question about the *authority* of the present, the interpretation of Being as present, which implies an implicit interpretation of time related to the domination of the 'now' over all the other modes or modalities of temporal experience. So I started with this problematic and tried to challenge Husserl's recurring statement about the *Ur-form*, the originary form of the living present. At the time, it was a way for me to describe phenomenologically *how* in the analysis of retention in Husserl something of the past, for instance, would resist this integration into a present, this being simply a mode of present; and on the other hand, it was a way

of questioning the concept of *life* in phenomenology—why *living* present? So everything started from that, with that problematic, and everything which followed in my work more or less came back to this problem. Which doesn't mean that I was simply breaking with Husserl or agreeing with Heidegger, but it was here a question of the present, of the interpretation of Being as present. So, I'm very grateful that you started with this 'nuclear' difficulty. We will find this question of the present coming back again and again through the aporias, the possibilities of the impossible, and so on and so forth.

Now, as a very general statement about the impossible and the aporia, since we are going to come back to these questions again and again, I would simply say that for me 'aporia', which is an old word, a Greek word that you find in Aristotle, belongs to the classical language of philosophy. It means in Greek, as you know, 'non-way', you cannot find your way: *a-poria* means that you cannot walk further, it's a blocked way, there is no way. And for me, in the way I try to put it to work, so to speak, to interpret it, aporia is not something negative, not something which in fact paralyses us, but on the contrary it is an ordeal, a test, a crucial moment through which we have to go, even if we are stuck, we have to experience this moment of aporia in order to make a decision, in order to take responsibility, in order to have a future, and so on and so forth. So for me the aporia, despite the apparent negative connotation is not simply a paralysis. The paralysis that it connotes, the aporia for me, is not paralysis, it is a chance; not so-called 'luck', but something which conditions affirmation, decision and responsibility.

The same would be true for what I call again and again the impossible, which I often write in two parts, with a hyphen, im-possible, which is not simply the opposite of the possible. So what I'm trying, in a very aporetic and painful way, with no light, in a very obscure element, what I'm trying to think, through the history of philosophy, through the memory of what we inherit as the history of Western philosophy, is what possibility means. We inherit a cer-

tain concept of the possible and the impossible, and there is a very thick stratification of layers which underlies this concept of possible and the impossible. In Greek, for instance, there is *dynamis* or potentiality, the opposition between actuality and potentiality: *energeia, dynamis, actus et potentia* et cetera. Again, without really totally agreeing with him—that is a very complex question—I am interested in what Heidegger says at some points about this concept of possibility. In the *Letter on Humanism* he says that we should not think of possibility the way Greek and Latin philosophy have interpreted it: as possibility against actuality or possibility against necessity.[4] And relying on the German word—*möglich*—he refers to the movement of love in *das Mögliche*, in the possible. For me, the experience of the impossible is not simply the experience of something which is not given in actuality, not accessible, but something through which a possibility is given. That is why in many different contexts—we'll probably address this question later on—in many different contexts, such as in the concept of forgiveness, of the gift, of responsibility we find this experience of the impossible. I have to say that what makes the gift possible, for instance, is its impossibility. For a gift to be possible, it must appear as impossible. If I give what I can give it is not a gift, if I do what is possible for me, if what I'm doing and deciding is simply what I can decide or what belongs to my possibility, if this is in me, then this is not a decision. If I give what I have, if I am rich enough or generous enough to give what is possible to give for me, I don't give. If I forgive the forgivable, I don't forgive. If I forgive what is possible to forgive, I don't forgive. So in order to give or to forgive, I have to go through the experience of the impossible, I have to forgive the unforgivable, to take this example, and to give what I don't have, what I cannot give. If I make a decision which I can make, that is something which I'm able to do, something which I'm strong enough or have the capacity or the ability to do, so that the decision then follows my potentiality, my ability, my possibility—then there is no decision. For a decision to be a decision, it has to be, to look

impossible for me, as if it were coming from the Other. So that's why the experience of the impossible is the experience of the possibility of such things as responsibility, gift, forgiving, and a number of other related things. So, just to start with this, I wanted to emphasise the fact that these words, 'aporia' and 'the impossible,' are not for me negative words, or neutral words, neutral concepts. But in order to demonstrate this in a convincing fashion, you have to rethink the heritage, to rethink what 'possible' may mean, what does it mean that it is possible for me to forgive only to the extent that it is impossible for me to forgive, what does 'possible' mean in that case? That's what we have to think...that's where thinking starts, where thinking is impossible. It is impossible, one cannot think...we cannot conceive of this...as a possibility. It is impossible, it's inconceivable, but that's exactly where one starts thinking.

Now, after these very general statements, let me go back to some more specific aspects of your challenging and powerful questions. About mourning first of all. Let me tell this in the form of a story, of a narrative, because it's easier for me, and probably for you too. I started to think about mourning after having, like all of us, read Freud, and also some writing in France by friends, psychoanalysts, who are dead now: Maria Torok and Nicolas Abraham, who devoted an important work to the work of mourning, trying to change Freud's interpretation. They proposed a couple of concepts, and I wrote an essay on their work entitled *Fors*.[5] They distinguished, in the work of mourning, between what they called 'introjection' and 'incorporation'. When you lose a loved one, then, during the work of mourning, you take the loved one in yourself, by idealisation, you, so to speak, swallow the Other, you take the Other in yourself, that's what we call a work of mourning. Then they said there are two ways of taking the Other in ourselves. In the one they called introjection, the Other becomes myself, or part of myself and the Other is assimilated; that is, there is an harmonious assimilation of the Other that I keep in myself, like a part of myself, with a narcissistic love, self-love for me, for the Other in me. That

is the normal and harmonious work of mourning—the Other becoming myself or myself becoming the Other becoming a part of myself. The other possibility is what they call incorporation, the pathological work of mourning, in which the Other becomes a part of yourself, but a part *in* yourself, but not a part *of* yourself, like a pocket of resistance which is a foreign body in your own body. It remains foreign, it remains unassimilated, so to speak.

I found this couple of concepts very interesting, very productive in many ways, but at some point I had to challenge the pertinence of this opposition because, I said, if I succeed 'normally' in the process of introjection then I am untrue to the Other, the Other simply becomes myself, and it's a way of remembering the Other by forgetting the Other. The Other becomes part of myself and I have a narcissistic relation to the Other in myself. That is a way of being, a *possible* mourning, but an untruthful, untrue mourning, an untrue memory to the Other. So for the working of mourning to be a real work of mourning, the mourning of the Other as such, of the loved one as such, or perhaps the hated one too, then it has to be incorporated. But the incorporation should not be total and in that case, of course, the Other remains foreign in myself, it remains Other, it doesn't become part of myself. I cannot appropriate the Other in myself, so it's a failure in a work of mourning, but it's also the only way of respecting the Otherness of the Other. So in that case, as you said very powerfully, you succeed by failing in a work of mourning, the only possible way of mourning is not to be able to mourn, is the impossible mourning. So, again, you have in relation to the Other, to the Otherness of the Other, the necessity of failing to appropriate the Other. And so the work of mourning, as a sign of fidelity, of truthfulness, must fail. And so possibility here, again, takes the form of the impossible. I cannot mourn the Other and that's what mourning should be; that is, the impossibility of accepting the death of the Other and of, let us say, inhaling it, or assimilating or appropriating it. So that is an example of the possible impossibility, where you cannot choose between the two. It's not

simply a contradiction. Of course, logically, it has the form of a contradiction. But it's the only possible, livable, acceptable contradiction, and the only possible ethics, because what is at stake here is respect for the Other as Other, as some Other whom one should not appropriate—the Other is not me, the Other will never be part of myself. This is something I learned or I verified or had confirmed to me again by Husserl, when, for instance, in the fifth of his *Cartesian Meditations*, about the *alter ego*, he insists that we never have any direct intuitive, originary access to the Other as such.[6] We never have an intuition of what is going on on the other side, only what he calls indirect 'appresentations', analogous hypotheses or appresentations. So for the Other to be the Other, he should remain outside, endlessly.

Now, I have to pay attention to the time, so I'll be brief. I'm sorry I won't be able to say much on the two other parts of your questions, but let me say something about messianic structure. Again, I agree with your analysis, but simply the word 'consciousness' that you added, twice in referring to a 'messianic structure of consciousness'—I'm not against it, but I'm not sure that I would keep the word 'consciousness' because this messianicity perhaps exceeds the space of consciousness. What I mean by 'messianicity' is the general structure of our relation to what is coming. Usually, we call this the future. This is an ambiguous name because, if by 'future' one understands a modality of the present, the present of tomorrow, then we would find again some reduction to the living present that I would like to avoid. So that's why I say 'to come' rather than the future. 'To come' means, on the one hand, that which is not yet here but which also might take the figure or the form of the one who arrives, not simply *what* but *who*—who comes? who is coming? This is what I call in French *l'arrivant*, the arriving one, the unexpected guest, for instance, the 'to come.' So, the messianic structure is the relation of consciousness, but also unconscious existence, to the unexpected surprise, to the unexpected. If I could anticipate, if I had an horizon of anticipation, if I

could see what is coming or who is coming, there would be no coming. So we are open to what is coming, which is not necessarily a good thing, the worst might be coming. That is why the messianic—I often insist on the fact that this messianicity is not a messianism—is not determined by the way that, in the Bible, we define the Messiah or Messianism. The messianic is a general structure in which the 'to-come' is absolutely undetermined, absolutely undetermined, and of course I cannot close, I cannot circumscribe this relation to the 'to come'. When I address political questions, in speaking of democracy for instance, I say the democracy 'to come' as opposed or as different to what we know today under the name of democracy. So your question, at the end of this development on the 'to come' and the messianic structure, was: 'can reflection on the messianic structure of consciousness help us live more constructively with uncertainty?' Because of the lack of time, my answer will be very brief: No. ... [laughter] ... No, it won't help...if it could help to construct, to live constructively with uncertainty, then the problem would be solved, we would know how to live constructively with uncertainty, there would be no uncertainty, or the uncertainty would be under control. Messianism means that the uncertainty is not and will never be under control, and should never be under control, so it doesn't help.

Lloyd:

Do you think that might not be a more positive way of living with it than thinking that we should try to control it?

Derrida:

Once I have said this terrible 'No', then we have to work...to negotiate with the 'No' [laughter] and to do whatever is possible to live constructively. That is what we are doing all the time, trying to be constructive. I try to be as constructive as possible, but without any certainty, without any assurance that at some point I am not wrong.

Otherwise we would transform our life, ethical life, political life, into an insurance system, and we cannot do it, unfortunately or fortunately, we cannot. So messianicity means that it's impossible to have this certainty. Indeed, this could be a good criterion to locate the difference between messianicity and messianism. In messianism you have at least the figure and identity of the Messiah—even if the Messiah is not here—you know what the Messiah should be, who he should be and so on and so forth. Whereas in the messianicity that I refer to there is no such anticipation. Now there will be a lot of problems, and still I go too quickly on this question, the relation between messianism and messianicity, but for lack of time I'll jump to the last question, perhaps we'll come back during the discussion to these questions.

Concerning the name, the desire of God which can coexist with the lack of belief in any determinate existing God: Yes, I think that no one, as a believer, as a man or woman of faith, would deny that there is no faith, no authentic faith without some, let us say, incredulity or some doubt, some lack of belief. I would not oppose faith to lack of belief. Again, to articulate this with the question of the possible or the impossible, in the book that you mention, *Sauf le nom*, I quote an extraordinary formula by Angelus Silesius which says: '*Das überunmöglichste ist möglich*'—the more-than-impossible or the 'most impossible', you can't translate that, the more-than-impossible or the most-impossible, is possible.[7] That is, God, as the most-impossible or the more-than-impossible, is possible. This ambiguity in the translation means that at the top of the possible— there is a line, you have the impossible and at the top of the impossible you have what is the most impossible or what is more than impossible, and of course, more than impossible means possible! [laughter] There is the most impossible which is possible, and that's the name of God: God as the most impossible or more-than-impossible, is possible. And in the line by Silesius you have the whole problematic, we should just stop here. I should have stopped there in quoting Silesius, he has said it all, but we have to go on. [applause]

Affirmative Deconstruction, Inheritance, Technology

David Wills:

By way of a parenthetical introduction, I'd like to say that the question I am going to put to Jacques Derrida are double. I'll repeat it: *the* question I am going to put to Jacques Derrida *are* double. Now I think you would have to be someone working in literature or something like that to be allowed such a formulation. You wouldn't be allowed such an ungrammatical statement in philosophy. But what I want to emphasise in that idea is something that has already come out of the discussion, both in the questions and the replies that Derrida has given: the notion that the sorts of aporia that we're talking about, the structures of possibility/impossibility that become explicit in a certain way in Derrida's work in the last ten years or so, really cannot and need not be separated from the same sorts of impossibilities that can be found lodged within the very fact of utterance itself. So that if we accept that language is always necessarily double, or always necessarily both communication and dissemination, always necessarily iterable—ideas which Derrida emphasised to a great extent in some of the early work and which he comes back to in terms of the aporia and the word 'iterability', which comes up an extraordinary number of

times in the works that are going to be quoted today, such as 'Force of Law' and other texts – then it follows that one will necessarily say something double, one will necessarily walk into an aporia the moment one opens one's mouth.[8]

So if the question that I am going to put to Jacques Derrida are double, it's simply because of that fact: it's a fact of language, the aporia, the problem, as he just pointed out, in terms of the question of decision, the aporia he talks about in terms of the undecidability which makes a decision possible, rather than leading to a paralysis which prevents decision—that aporia is not, I think one can say, with respect, something that Jacques Derrida invents, and perhaps not even something that he finds or discovers, it's something that *is*, something that *emerges*, something that is passively dealt with to the extent that it is lodged within the most single and simple utterance.

Now, the question or questions that I want to pose derive from a context that is established, in particular, in three recent texts, first of all *Specters of Marx*, and then in a discussion with Bernard Stiegler in a book called *Échographies* which develops out of that same context, and refers, to a great extent, to *Specters of Marx*.[9] And then thirdly, the reformulations of some of these same ideas which come out of the essay in the text on religion, called 'Faith and Knowledge'.[10] If I can summarise that context by quoting Derrida in *Échographies*, talking about *Specters of Marx*:

> In *Specters of Marx* I begin an explanation based on Marx's text, and oriented by the question of the 'spectre', in a network with those of repetition, mourning, inheritance, event, and the messianic—everything that exceeds the ontological oppositions between absence and presence, visible and invisible, living and dead, and, therefore, especially the matters of the prosthesis, as phantom limb, technics, the tele-technological simulacrum, the synthetic image, virtual space, etc.[11]

Now you can see that quite a wide context is drawn in that summary Derrida makes of *Specters of Marx*. What I want to concentrate

on in these questions is the possibility of bringing together, let us
say, three elements of that complex network: the idea of inheri-
tance; the idea of how that relates to the technological, and then
relate that to some extent to questions concerning religion and the
messianic, the groundwork for which has already been developed.
What emerges in *Specters of Marx*—but, once again, one can look
back to other works such as *The Other Heading*, or *Aporias*, one
can go further back still, to a text like *Parages*, the series of essays
on Blanchot, or an essay from 1980 'Of a Newly Arisen
Apocalyptic Tone'[12]—what emerges out of all that are two things, it
seems to me. First, a re-explicitation—if I can use that word—an
attempt to render explicit what can be described as an 'affirmative
deconstruction' (and all of the questions, all of the discussions
today, I think, relate to that idea), in terms of the democracy-to-
come, promise, hospitality without reserve, an ethics of the relation
to the Other, and so on, what he refers to, quoting again, from
Specters I think, as 'a certain emancipatory and *messianic* affirma-
tion, a certain experience of the promise that one can try to liberate
from any dogmatics and even from any metaphysical religious
determination, from any *messianism*'.[13] There he makes explicit the
distinction just referred to between the messianic and messianism.

So the first thing that emerges is that re-explicitation of an
affirmative deconstruction, and the second thing, something that
came out in the discussion last night, in Alan Cholodenko's ques-
tion: a spectrology or spectography, a sort of 'hauntology', as
Derrida refers to it, that would be a reading of, and a function of,
that aporetic promise, its disjunction, its out-of-jointedness, and so
on.[14] In *Specters of Marx,* and the other texts I just referred to, this
is articulated particularly around the question of inheritance, the
idea of what comes, what is given in the *dis*junction of a bequest or
inheritance. Now, of course, that repeats the sort of aporetic struc-
ture we've been talking about: an inheritance is something one pre-
sumes to arrive directly from the person or the structure or the event
that made that bequest; when somebody leaves something for you,

it is supposedly for you alone, it is supposed to be received by you, but it necessarily doubles as something unexpected, it necessarily arrives within the structure of the unexpected, it is something that cannot be controlled in its singularity. And for me, the most striking thing about inheritance, as expounded in *Specters* and again in *Échographies*, as I've already suggested, is the extent to which Derrida relates it to technology, and to the aporia that derives from the structural opening to technology that is a function of iterability, repeated in many contexts throughout his work. So I'll quote again, this time from *Échographies*:

> In its classical sense, an inheritance always passes from one singularity to another. Without singularity, there is no inheritance...From this point of view, technics, or technology, threatens inheritance. But the converse also has to be stated: without the possibility of repetition, of reprise, of iterability, thus without the phenomenon and possibility of technics, there is no inheritance either. There is no inheritance without technics. Inheritance is therefore in tension with technics. A pure technology destroys inheritance, but without technology, there is no inheritance.[15]

If something is received automatically, if an inheritance is received automatically, in the sense of a pure technology, then there is no inheritance. By the same token, an inheritance, to the extent that it is the example *par excellence*, of a technology, of a machine, of something which functions after the death of its author, acts in a sort of automatism.

Now in the discussion in 'Faith and Knowledge' it becomes clear that, in terms of the aporia just outlined, the promise, the messianic, the *à venir* (to-come) all share the same structure as that of faith, belief, and other ideas that we would more traditionally perhaps relate to religion. Let me quote from 'Faith and Knowledge':

> There is no discourse or address to the Other without the possibility of an elementary promise, but perjury and broken promises claim the same possibility. Thus there is no promise without

the promise of a confirmation by means of a 'yes'. This 'yes' will always imply the reliability or fidelity of a type of faith. There is no faith, then, and no *avenir/à venir*, without what iterability presumes in terms of the technical, the mechanical and the automatic.[16]

So following on from that constant reference to the technological in those texts, the first part of my question would deal with how and whether one can interpret the technological structure of the aporia of inheritance, of faith or of the promise as something affirmative. In 'Faith and Knowledge', in fact, Derrida calls technology or technics the 'chance' of faith, but also its greatest risk.

Now the reason I pose this question, the reason I ask how, or whether, the technological structure of the aporia of inheritance can function as something affirmative, is that in those very same texts that I just referred to, most of the discussion that Derrida has concerning technology, most of his references to the tele-technolological forms that are dominant today—the media etc—are to something that is other than hospitable, it would seem, in Derrida's sense of the term 'hospitable'. Whereas he is careful to distance himself from the anti-technological side of Heidegger, if you like, the 'earthbound' Heidegger, when he talks about technology, the references Derrida makes in those texts to such things as the transformation of public space, of decision making, the transformation in the functioning of governments, the mediatisation of religion, the reactive rise of nationalisms and fundamentalisms, the valorisations of the body (even if those function by means of the violation of the body), which is therefore supposed to be immune from technological effect, all that, as well as the problems of the time, or lack of time, given to intellectual debate, the media's naïve presumption of immediateness, and then such things as Derrida's own uneasiness in front of a camera or a microphone, all those things seem to leave very little room for something like an affirmative technology.

So, therefore, to repeat the first part of the question: given that there is no faith, promise, etc, without the technological, how

would one articulate in your terms such a thing as the 'chance' of technology, a technological 'promise', a technological *avenir/à venir;* and then secondly, given your refusal in 'Faith and Knowledge' of the opposition between so-called 'non-religious' thinking—philosophy, the Enlightenment—and religion, in terms of the structures of iterability and technicity just outlined, is it not possible that an emphasis on some sort of affirmative technology is a strategically necessary thing in order to liberate, in your terms, 'a certain experience of the promise' from any dogmatics and even from any metaphysical religious determination, from any messianism? Can one read your emphasis on the necessarily technological structure of promising, professing, witnessing etc as some sort of antidote to the risk of messianism?

Derrida:

Thank you. I will try to draw the line in what you said between what, in the text you quoted, is already an answer to your question and what is not. I'm not sure that I am able to identify this line, but let me try. For instance, at the end you ask if this leaves room for something like an affirmative technology, and my quick answer would be: yes, it leaves room, but little, and how little, what does 'little' mean here, that's what I should explain, so I will try to make it clear. Very little.

Apparently, in principle, if one understands technology as your question often did, as equivalent to the machine, the repetition, and so on and so forth, there is no room left for affirmation, inheritance, and so on and so forth. But perhaps what is at stake here is not technique itself but technology, our experience of technology, our relation to technology. Of course machinery in itself, an instrument or a mechanism, leaves no room for an affirmation. A pure system of repetition with no 'iterability'—as you know I distinguish between repetition and iterability, iterability means repetition and difference, and alteration, and singularity. In iterability, in the logic of iterability, you have repetition, mechanical repetition, and trans-

formation and thus singularity—some event. The uniqueness of the event as repetition or within repetition. So, if by technique we understand only machinery, mechanism, there is no possible affirmation. If by technology, the history of technology or our experience of technology, we understand the invention of machines to come, then it's different. If I relate these to the problem of inheritance, no doubt there is no inheritance without some repetition, some mechanism; that is, there is a given, there is a language, if you inherit a language or the history of philosophy, anything, there is a part of inert repetition. But, as I often try to recall, so to speak, inheritance is not reducible to receiving. When we inherit, we don't simply passively receive something. We choose, we select, we reaffirm. So at the heart of the experience of inheritance you have a decision to reaffirm, to select, to filter and to interpret. There is no inheritance without some interpretation and some choice, which means that you never inherit passively everything which is given to you. You make a decision to be true to the past and to choose and interpret, and so there is an initiative. So from that point of view our relation to inheritance is analogous to our relation to technology. Technology is not simply technique, it is not simply a set of instruments that simply repeats. We experience what we call *techné* or technology in art and in industry or in all kinds of technology as something which comes from the future. There is nothing more risky than technology. We have a relation to technology, if only to our current technological world, as something we cannot master. It is full of hopes and dangers and so our experience of technology is as risky, as open to the 'to come', as the experience of inheritance. So from that point of view, choice, responsibility, active interpretation are also as well on the side of inheritance as on the side of technology.

Last night I tried to suggest in relation to prosthesis—and I'm sure that you understand this best because you're an expert in the logic of prosthesis[17]—that if there is no technology without some prosthesis, prostheses, some prosthetic structure; and if one

agrees that this prosthetic structure is not something we add to the "proper" body but that it is already our experience of what is most proper to us, it is already a possibility of the prosthetic. If thus technology or *techné* is already originally in place in our own body, in what is most proper to us, then everything we said today about responsibility, the possible/impossible, the impossible/messianic, has to do with technique, and from that point of view if there is an affirmation it has to do with some technology, affirmative technology. So when I insisted—I think in many places—on this affirmative relation to technology, it is always first of all, as you recalled, not to be in the position of this reactionary resistance to technology. We have to affirm the to-come in the form of technology. If there is a future, if there is a future, if there is a to-come, it will happen indissociably with a transformation of the world by, through or within technology, and we know this today more than ever. It has always been true, but today we know that the to-come will come to us in the form of a new technology. So the technology is not simply a set of instruments external to our life, our temporality, our decision and so on and so forth. So from that point of view, I cannot dissociate the problematic of affirmation from the problematic of technology. Otherwise the discourse of affirmation would be a traditional discourse on some spiritual ontology, a spirit foreign to the body, to the technique and so on and so forth, and that is exactly what I would like to avoid.

Now, this doesn't mean that it is easy, that there is a lot of room left. There is little room left, of course, that is why there is a debate. There are terrible decisions to make about technology because, as this blind and cruel set of powers, technology might mean death, repetition, and then the condemnation of what we call affirmation, hope, messianicity and so on and so forth. So we have to struggle not to reject technology and not to be buried under technology. That's where the responsibilities have to be taken in the most difficult situations today. You understand that what I'm referring to is a very concrete and compelling situation. We have to

make decisions everyday about the way we organise our environment, our inscription in a high-tech, a hyper-technical world. If I had time I would try to show that even if there is something absolutely new today in this situation—and I would not neglect this mutation, this novelty—nevertheless this was already true in a different way in the time of ancient Greece, or in the Bible when the question of the Messiah had this form, the form that we know, already there was a question of inheritance and technology, and from that point of view it's not new. That is why, coming back to our point of departure a moment ago, I insist on inheritance: because it is often through memory, through the endless and groundless return to the past that we are faced with the most unpredictable future. The most unpredictable future may be hidden in a past which has not yet been re-presented or made present or remembered, so from that point of view I would not dissociate between the to-come as future and the to-come as hyper-past, more than past, a past—as Blanchot and Levinas often say—a past which is not a present past, a past present, an immemorable past. The risk, the adventure comes as well from this absolute past as from the absolute to-come. And I would not dissociate this from the problem of spectrality, technology and so on and so forth.

Justice, Colonisation, Translation

Paul Patton:

One of the most powerful examples of deconstructive affirmation appears in your essay 'Force of Law'. In summary form, this affirmation is the statement that 'deconstruction is justice.'[18] In its more developed form in that paper, it is the claim that deconstruction corresponds to a double movement which involves, firstly, a responsibility towards the history, origins and therefore the limits of our concept of justice; and secondly, it involves a responsibility toward the very concept of responsibility, and therefore towards the network of concepts in which our concept of responsibility is embedded, concepts like the notion of the will, of freedom, of property, the self, and consciousness, and so on. Already in that second movement—responsibility toward the very concept of responsibility—there is more than a hint of paradox.

Now, my question is about justice in the context of colonial social relations, and I want to raise a number of issues which have the form of a series of nested questions going from the less specific to the more specific. I should say that I was encouraged to ask this question about how we might think of justice in a colonial context not only by your willingness to make comments about 'apology' in a press conference in Melbourne, but more generally, before that,

by *Monolingualism of the Other*, a text which you gave at a conference on language and its relation to culture and cultural identity.[19] One of things that struck me in that text was your account of your own experience of coloniality, in particular in your relation to metropolitan France and to the French language. Reading that account, I thought that not only was this an appropriate question but also that, since many Australians share a similar relation to Britain and to the English language, this might be an occasion to reassure you that here, too, you are among colonials.

In 'Force of Law', you contrast the law, which is deconstructible, and justice, which is indeconstructible. This distinction has particular pertinence in Australia, at present, since a recent decision by the High Court which recognised, for the first time, a form of title, a form of ownership of land, based on indigenous law and custom.[20] This decision overturned the non-recognition of any form of ownership based on indigenous law which had become embedded in British and then Australian law since the establishment of the colony in 1788. So, it provides a striking example of a partial deconstruction of an established and historically contingent body of law, in the name of justice towards indigenous people. But, of course, at the same time, and to the extent that this involves a judgment formulated in the law of the colonising power, this act of justice toward colonised indigenous peoples presupposes the perpetuation of a fundamental injustice.

So it seems that at issue here is the aporetic character of all justice, the sense in which—as you say—justice, even when it is realised, is inseparable from the non-realisation, the non-attainment, of justice, or the perpetuation of injustice, we might say. It is for these reasons, among others, that in 'Force of Law' you describe justice as 'the experience of what we are not able to experience' or as 'an experience of the impossible'.[21] Now, some readers and commentators will no doubt remain dissatisfied by this negative and apparently indeterminate mode of affirmation, by the fact that affirmation is undertaken only by way of this description of an experi-

ence of aporia which—as you said earlier—is precisely a no-way. This leads some to ask what is the point of such an affirmation, an affirmation which offers only, as you put it in *The Other Heading*, 'the thankless aridity of an abstract axiom'.[22] Similarly, in *Aporias*, you ask yourself to justify this reliance upon the negative form in the following terms: 'Why this language, which resembles—not by chance—that of negative theology?'. And the answer that you give is direct and straightforward: 'Because one must avoid good conscience at all costs'.[23] In other words, the commitment to a given positive form—whether of justice, of community, of hospitality— may reassure the conscience of oneself and others, but it does so at the cost of this experience or awareness of, as you put it, 'the absolute risk that every promise, every engagement, and every responsible decision—if there are such—must run'.[24] So, the more general, less specific, question that I want to ask is: what does this experience of absolute risk, this experience of the impossible, imply with regard to how we might think of justice towards the colonised other?

The second question bears on positive concepts of justice themselves. In your discussion of justice in 'Force of Law' you privilege Levinas's definition of justice as the relation to the Other, and it is in terms of *this* concept of justice that you outline the different forms of aporia to which justice is subject: the aporia of decision, the aporia that is involved in the attempt to do justice towards a particular case but in terms that inevitably refer to universal principles, the difficulty that one faces in doing justice toward the particular in terms of the universal which does not and cannot speak directly to that particular case. It is in terms of this concept of justice as relation to the Other that you set out the aporia of justice. I wonder whether we should not refrain from calling this a 'concept' of justice, partly because this would suggest that it is simply one alongside other positive concepts of justice, such as John Rawls's distributive justice. Justice as relation to the Other is perhaps not so much one concept of justice alongside other concepts, but more like

a transcendental form of justice in terms of which these other positive concepts may be understood. In this sense, we may be able to understand 'the experience of what we are not able to experience' or the 'experience of the impossible',[25] as the name of a kind of reserve which is not exhausted by any particular positive concept of justice. Or take another positive concept of justice, namely justice as reparation for *past* wrongs or past injustices. One way to understand what this requires would be to suppose that it involves the restoration of the *status quo*, such that things should be as if the injustice never took place. Now, in the colonial context, of course, this is, quite often, simply not possible. Another, more realistic, approach might be to seek to redress the disadvantage presently suffered by victims, or descendants of victims, of injustice such that it would be as though the past injustice had never occurred. But, again, even supposing this were possible in political and logistical terms, it clearly doesn't exhaust the requirement of justice conceived in terms of the relation to the Other. What about, for example, the demand for apology, for the gesture involved in the recognition and acceptance that injustices were committed? In more recent work you suggest that apology or forgiveness is also subject to aporia—and indeed you mentioned this in your response to Genevieve Lloyd's question—to the extent that in the case of forgiveness one never seeks forgiveness for the forgivable, as you put it, one only ever seeks forgiveness for the unforgivable.[26] So, my second question is: what is the relation of this aporia surrounding apology and forgiveness to the aporia of justice, and what do these imply, again, with regard to how we might think about the prospect of reconciliation in the colonial context?

Finally, let me refer briefly to the figure of translation that recurs throughout your discussions of aporia. In 'Force of Law' there is the passing remark that a translation is 'an always possible but always imperfect compromise between two idioms'.[27] This remark reminds us that, while justice itself is an experience of the impossible, just acts, like translations, are not only possible but

occur regularly in the law and in everyday life. In *Aporias*, too, the question of the translatability of a sentence given out of context serves to remind us that there is translation not only across the borders between languages, but also across the borders within a given language: you speak there of a border of translation which does not only pass among various languages, but which separates versions of the same sentence within one and the same language. The effect is to remind us that languages are subject to the same condition of non-self-identical identity that we find in the case of cultures or persons. In *Monolingualism of the Other*, at one point, you describe the antinomy set up by the two statements, 'We only ever speak one language' and 'We never speak only one language', as 'not only the very law of what is called translation. It would also be the law itself as translation'.[28] So, and this is my final and more specific question: how should we understand the law as translation and how does it relate to linguistic translation?

Derrida:

Thank you. Well, as everyone in the audience realises, as we do on this side of the table, the discourses are what counts here because what I am able to add after this elaborate set of remarks, questions, interpretations, are only just minute post-scriptum. I accept this situation, really, and I ask for forgiveness for this [laughter]...this vulnerability. So I'm going to confess from the very beginning, as I did just before the session, that I'm not sure I have what could be called 'a concept of justice' which would be consistent enough to cover all the texts and contexts that you refer to—the reading of Levinas, 'Force of Law'—and if I had time I could reconstitute these contexts in which I had to adjust the word justice, the quasi-concept of justice to very different contexts, without being simply empiricist or simply relativistic, but trying to regulate something which is very obscure in my view of what we should call justice. So now, the fact that I perhaps don't have a single general concept of justice doesn't mean that there is one somewhere and that we should rely on such a

concept. Perhaps the aporia lies within the drive for justice, which implies on the one hand a respect for universality, and on the other hand for singularity—you cannot be just for everyone and for every single one, and in the context of Levinas, that is the fate which we face. I have to be responsible for the Other and just for the Other in a face-to-face relationship, in a dual relationship, but if I am true to this other single one, if I am just with this, I am already betraying a third one. Levinas often says that the desire for justice, the call for justice is always in the name of the third party: justice in the sense of the law, of the institution, 'comparison', politics and so on and so forth. So I'm very very embarrassed with this concept of justice. In *Specters of Marx* I discuss Heidegger's concept of *dikē*, the interpretation of *dikē* and I try to challenge the way he interprets *dikē* as harmony, as symphony, in a certain way, since I think that there is no justice without some interruption and some disproportion. So it is a very difficult problem for me, and I won't hide that I have difficulty in having a logically consistent discourse on justice.

Nevertheless, I would not avoid, in the name of these general protocols, the specific question with which you started, related to what you call the 'colonial context', this colonial context. The question I always have, that I would ask myself is: what is a colonial context? That is, is there any culture, any society in the world which is not colonial? I'm sure there is no non-colonial society, which doesn't mean that having said this we have simply to forget the differences and to think that every nation-state, every society, is equally colonial in the modern sense of the word. No doubt Algeria was a colony in a way in which France, today, is not a colony. But...France is a colonial structure and the United States is colonial through and through in different ways. So the difference here is not between colonial and non-colonial structures, but between different sorts of colonial structures, and I understand of course that Australia is a very specific type of colonial structure. If I can come back to the example that you gave about the decision made by the High Court: of course in that case there was a partial reparation, a

partial act of justice, but since, as you said, it was phrased and produced in the name of the coloniser, it was still an injustice. And here you have an example of the paradoxical relationship that I try to formalise between the law and justice. On the one hand, you have the law which is deconstructible; that is, the set of legislations, the set of positive laws which are in constant transformation. They are deconstructible because we change them, we improve them, we want to improve them, we can improve them. For instance, the Declaration of the Rights of Man has been improved for the last two centuries, there have been a series of declarations which have added new rights for the workers, for women and so on and so forth. So we can improve the law, the legal system, and to improve means to deconstruct. It is to criticise a previous state of the law and to change it into a better one. That is why the law is deconstructible. On the other hand, justice, in the name of which one deconstructs the law, is not deconstructible. So you have two heterogeneous concepts, if you want, two heterogenous ends, the law and justice.

Yet, despite this absolute radical heterogeneity between the two, they are indissociable. And, in different contexts, I re-formalise the relationship between two terms, the two poles of this structure, which are absolutely, radically heterogeneous and nevertheless indissociable. Why? Because if you want to be just, you have to improve the law. And if you improve the law—that is, deconstruct the previous system—it is in order to be more just, to tend to justice. But in the middle, you have to negotiate, you have the least bad law. The example that you gave was not pure justice, but it was a negotiation to improve as much as possible a given state of law, but in the name of justice. But of course it's not just. We cannot have good conscience, and obviously you don't have a good conscience about that: it's not enough, but it's better than nothing. And so, deconstruction goes on, and it will be an endless process. The difference or the heterogeneity with no opposition—justice is not opposed to the law, and the law is not opposed to jus-

tice—between the two will remain endlessly open, endlessly irreducible. It is in this sense that I say that that justice is undeconstructible, because it is in the name of justice that we deconstruct, and you cannot deconstruct that in the name of which you deconstruct, OK? But this doesn't mean that the given set or the given stage of a deconstructive discourse cannot be deconstructed. You can deconstruct a given strategy of deconstruction, there is a given shape of what we call deconstruction that can be deconstructed. But that in the name of which one deconstructs, of course, cannot be deconstructed.

Now, of course I won't be able to address all the questions of justice that you raise, for there would be a lot to say about colonisation, about culture and colonisation. In *Monolingualism of the Other* I recalled that culture and colonisation have the same root: a culture is a colonisation, there is always someone else having more power than the other, who imposes his language, his force, his name and so on and so forth. Nietzsche explained that the master is the one who coins the language, who imposes the language, so there is no culture in which at some point there was not violent imposition of the language. Then, after a certain time, things can be pacified, we just forget the initial violence, but at the beginning of every society, every nation, every nation state, there is a violence…it would be too easy to demonstrate this.

Now, to get quickly to the last part of your question about translation and the law. Just in passing, and too quickly, I don't think that there might be an absolute reconciliation anywhere and especially not in what you call a colonial context. Things will go on, there will be phases in which of course the war will be less visible or cruel or lethal, but why should one reconcile after this terrible violence which has founded a colonial…any society as colonial? You see, each time I refer to forgiveness—that is an enormous subject—I try to dissociate myself from the tradition that we inherit, that is the Biblical, Jewish, Christian and Moslem tradition of forgiveness, and stand against what is prevailing in this tradition:

namely, the fact that forgiveness should be asked for through repentance, confession, transformation and in view of reconciliation, salvation, redemption and so on and so forth. I try, against this prevailing part of the heritage, of the tradition, I try to show or to affirm that a pure act of forgiveness should be totally dissociated from any horizon of reconciliation, salvation, or the economy of 'healing away' as they say in South Africa. We are reconciled or we forgive or declare amnesty and so on and so forth, we establish a commission of truth and reconciliation in view of 'healing away' or curing the traumatism, which is a good thing, but I wouldn't call this forgiveness. Of course we have to do whatever we can to reconcile, to heal away, to make the society work and so on and so forth, if it is possible, but we shouldn't call this forgiveness. A pure act of forgiveness should be totally free from any perspective or attempt or research of reconciliation or salvation, from any such form of benefit. It should be absolutely gratuitous, gracious. So if there is a reconciliation in the colonial context, this doesn't require forgiveness, that is something else, some other process, and if there is forgiveness, it doesn't necessarily lead to reconciliation.

Now, about translation. In this short book, *Monolingualism of the other*, when I say that I speak only one language, I have only one language, and that this language is not mine—which is a contradiction in terms—on the one hand, I describe a very specific colonial context in which I was born, with a number of very singular features. I won't recall these here, but this is common to people like me, in my generation, at a very specific moment in Algeria, in a colonial Algeria, a Jewish community and so on. I won't describe this. But, on the other hand, I had the feeling that this singular structure was exemplary, universal, in the sense that everyone in any context, colonial in this sense or colonial in another sense, could say the same thing. I have only one language, a mother tongue as they say, a mother language, and the language is something one cannot appropriate, it is never mine. A language is structurally the language of the Other. Even if you were not born, like

me, in a Jewish community and brought up in French schools, colonised on the one hand and on the side of the colonisers on the other hand...even if you're not in that situation, if you were born French, in France, with a French family for generations, nevertheless, the language you speak would not be yours. That is the structure of the language. So I had constantly in that book to handle this structure, this situation in which you have to take into account the irreducible singularity *and* its exemplarity, the universal structure to which it belongs. This is why singularity is translatable and untranslatable at the same time.

And of course this is the law of the law, because the law implies on the one hand universality—there is no law as such which is not a claim to universality—and at the same time the law prescribes—I'm thinking of the law in the religious sense, in the ethical sense, in the juridical sense—the law implies the taking into account or the attention paid to absolute singularity. Then you have to translate the singularity into universality, you have to translate the languages, and of course if you translate this law of translation to what you call the colonial context, then what can we do? This is the case in Australia, but it's the case in France too; what can we do with people who either arrive in your own country or where they're in their country before we arrived and when a language becomes dominant, prevailing, and that the dominated part of the society has to translate itself in the dominating language? The everyday situation is the situation in which...let's say an immigrant in France, let me take a French example, someone who comes from Algeria, a worker, an immigrant, who doesn't speak French very well, and who is charged with something, who has to appear before the court, not knowing the language, not knowing the law, and yet nevertheless subject to the law, to the French law, which means memory, history and the French language. Then the main moment in this experience is the moment of translation, and we know how dramatic it may be.

Similarly, in the example that you gave at the beginning, it was also a problem of translation: the decision of the High Court was of course going in the direction of the Other, and of the Other's language, but remaining in its own language which is not simply a linguistic element but a set of axioms, values, norms and so on and so forth. Then you have this negotiation to be as just as possible while remaining in your own language—you cannot try to be just by or while forgetting your own language, you cannot speak purely and simply the language of the Other. If I want to be just with the Other, and hospitable to the Other, I have to some extent to go on speaking my own language, but in a way, in such a way that my own language opens itself to the Other's language, transforms itself. Sometimes it's a very concrete situation—I know this in France, I am sure you have examples here—where the French language, the French body, the body of the French language is transformed by many graftings, many grafts from North African languages for instance, and so on and so forth. So that's translation inscribed within the body of the language.

Hospitality, Perfectibility, Responsibility

Penelope Deutscher:

My questions will be directed at Derrida's work since 1996 on the theme of hospitality, which has been discussed in the context of ancient Greek notions of hospitality, in a biblical, Judeo-Christian context, in Kant's work, in a reading of Levinas, in work on Arendt, but also a series of roundtables and discussions which have touched on issues of immigration and asylum, xenophobia and the illegal resident. I'm thinking of short texts such as *'Fidélité à plus d'un'* in *Idiomes, Nationalitiés, déconstructions (1998)*, and those in *Manifeste pour l'hospitalité* from 1999.[29] In the latter work, Professor Derrida, you asked the question: is unconditional hospitality possible? And you wrote that,

> In the hospitality without conditions, the host should, in principle, receive even before knowing anything about the guest. A pure welcome consists not only in not knowing anything or acting as if one knows nothing, but also in avoiding any questions about the Other's identity, their desire, their rules, their language, their capacity for work, for integration, for adaptation... From the moment that I formulate all of these questions, and posit these conditions . . . the ideal situation of non-knowledge—*non-savoir*—is broken—*rompue*.[30]

So an unconditional hospitality would have to be offered to an unlimited number of unknown Others, to an unlimited extent. And to Others to whom no questions were posed. It fails as such if it's offered only under duress, or to fulfill a debt, or out of legal or moral obligation. In an unconditional hospitality, the Other whom we welcome—Derrida has proposed—'might be an assassin, might disrupt my home... might come to make revolution'.[31] And, it must be added, one must welcome that possibility. Our welcome would not be contingent on interrogations about the Other's identity, leading Derrida to ask, in *Of Hospitality*:

> Does one give hospitality to a subject? to an identifiable subject? to a subject identifiable by name? to a legal subject? Or is hospitality *rendered*, is it *given* to the Other before they are identified, even before they are (posited as or supposed to be) a subject?[32]

Perhaps those formulations seem to call—come, *viens*—to the absolutely Other to whom I might offer a pure hospitality. But Derrida is not offering a manifesto for how to offer this, for he argues that the project would always have failed. Pure hospitality is, he writes, impossible. Impossibility is not what prevents a pure hospitality one might dream for it's included in the structure of what pure hospitality is. Among the reasons for this there is his comment cited above that 'from the moment that I formulate all of these questions, and posit these conditions . . . the ideal situation of non-knowledge—*non-savoir*—is broken—*rompue*'. Is it possible to turn to the Other at all without posing some kind of question: even just the what? or the who? So, hospitality offered would always 'annul' itself. And there's a sense in which, as Derrida writes in *'Fidélité à plus d'un'*:

> There is a certain original mourning: the Other does not present itself, but absents itself even as it presents itself, the Other is one of the disappeared (*c'est un disparu*). When I see the Other appear, I am already weeping the Other's absence, to deplore-desire-apprehend their departure, here I am (*me voilà*) already saying: farewell, farewell, you abandon me (*adieu, adieu, tu m'abandonnes*).[33]

I never greet the absolute, anonymous Other whom an unconditional hospitality might have welcomed.

Perhaps we need to ask not whether the politician, or anyone, should think about a poetics of unlimited hospitality—but how the politician, or anyone, is already engaged, if implicitly, in this reflection. Perhaps some, or all of us, do live believing in the possibility of unlimited hospitality. Though, in fact, I'm not thinking of those whose intentions might be to say: *viens*—'come'. I was thinking of those also who have wanted to say: *ne viens pas*, 'don't come'. Those wanting to limit immigration programs often evoke unconditional hospitality as a threat: a flood of immigrants might be admitted, temporary visitors might never go home, they might be assassins, they might contribute to unrest, the nation's identity might be lost in the numbers. So if we're told, as we are, that we must draw the limit, let's assume that acts of limited hospitality do live with, and do bear the trace of, the possibility of unlimited hospitality, and apparently the belief in that possibility.

In *Of Hospitality*, Derrida associates instances of xenophobia with the fear that one's home will no longer be one's own domain, one's inviolable private space. He writes: 'the perversion and pervertibility of this law (which is also a law of hospitality) is that one can become virtually xenophobic in order to protect or claim to protect one's own hospitality, the own home that makes possible one's own hospitality'.[34] And in *'Fidélité à plus d'un'*, the *Manifeste de l'hospitalité* and in *Monolingualism of the Other*, Derrida resists the positing of national or cultural identity as that which is proper to us, that which we can possess or speak for. In *Cosmopolites de tous les pays, encore un effort!*, contributing to the proposal for a network of cities independently offering asylum to persecuted intellectuals amongst others, Derrida proposes that such urgent 'practical initiatives' should also open up 'an audacious call for a true innovation in the history of the right of asylum or of the duty of hospitality'.[35] What kind of new notions of responsibility might be opened up by a new concept of the *chez soi*, and so a new concept of hospitality?

For if hospitality assumes that we must be able to offer access to something we legitimately possess, a territory proper to us, to an Other supposed at its exterior, if these are its conditions, then hospitality is again impossible. A nation state is never properly itself, its territory is never its own, and this can be thought in many ways in cases of the literal colonial history of a country such as Australia, and in a kind of generalised colonialism which Derrida has argued, in *Monolingualism of the Other*, and *'Fidélité à plus d'un'*, pertains to all cultures. So, in proposing its rethinking as impossible, Derrida also speaks to a rethinking of concepts that hospitality seems to presuppose: one's proper residence, one's proper identity, one's proper cultural identity. What forms of hospitality might open up once it is thought of as impossible, through the reconception of these terms (one's proper residence, one's proper identity, one's proper cultural identity)? Derrida asks, for example, what new ways of thinking responsibility might open up from a notion of responsibility as 'responding for and to what will never be mine.'?[36] In an Australian context, this could have a particular resonance, as our Prime Minister John Howard disclaims as not properly his the history of colonial violence in Australia, as if one would be responsible only from the starting point of that kind of property demarcation.

Two statements come together in Derrida's recent work: One is the statement from *Cosmopolites de tous les pays* that hospitality is culture itself (*'l'hospitalité, c'est la culture même'*);[37] the other is the statement from *Monolingualism of the Other* and *'Fidélité à plus d'un'* that all culture is colonial (*'toute culture est coloniale'*).[38] This suggests that the problem of the original coloniality of cultures must be thought with the problem of hospitality, and so I'd simply like to ask how these issues interconnect? How can the problem of the original coloniality of culture be thought with the problem of culture as hospitality? Finally, how does the etymology of hospitality—*hospes*, the stranger or guest, but also the host or master[39]—give another sense to the claim that hospitality is impossible? For example, would it be impossible to master the stranger?

One last question: about references that you've made to the term 'perfectibility'. You've commented: 'Hospitality is . . . immediately pervertible and perfectible: there is no model hospitality, only processes always in the course of perverting and improving, this improvement itself containing the risks of perversion'.[40] And you've also made a comment in *'Fidélité à plus d'un'*: 'I believe in historicity and so in the infinite perfectibility of law'.[41] And I wanted to ask, on the basis of some of the other discussion that's taken place this afternoon, how one could also start to think of the messianic, of messianicity, in terms of perfectibility, as containing both the possibility of improvement, but also the constant possibility of risk, or the unknown, but also in the sense of degradation, of what one doesn't hope for. Could perfectibility be another term for messianicity?

Derrida:

Thank you. Let me start with, let's say, a very well located, punctual, question, among all the questions that you've asked today, all of which are essential and very difficult. It's about the two assertions, one that hospitality is culture itself, and that all culture is originally colonial. Are these statements incompatible or in tension or not? When I say that hospitality is culture itself, I don't mean pure unconditional hospitality; that is, I was referring to the fact that there is no culture without hospitality. I don't like the word 'culture', because it's a very obscure and vague word, but let's say of a society which shares a language, a memory, a history, a heritage, and a series of rites, rituals, norms, habits and customs that we know of no such society, no such culture, which would not claim that it is hospitable; that is, that it has some room left for the stranger who arrives, who is invited. So hospitality in that case is part of being at home; there is no home, no cultural home, no family home without some door, some opening and some ways of welcoming guests. But in that case the hospitality is conditional, in that

the Other is welcome to the extent that he adjusts to the *chez soi*, to the home, that he speaks the language or that he learns the language, that he respects the order of the house, the order of the nation state and so on and so forth.

That's conditional hospitality—in a colonial structure in which there is a master there is someone who is the host. As you will recall, the word host means *hospes*, means the master, sometimes the husband, the male master of the house, and in that case we have conditional hospitality. To which I—I won't say 'oppose'—but in contrast to which I try to think pure and unconditional hospitality, the idea of a pure welcoming of the unexpected guest, the unexpected arriving one. From that point of view I would distinguish between the hospitality of the invitation and the hospitality of the visitation. In the invitation, the master remains master at home, *chez soi*, and the host remains the host and the guest remains the guest, the invited guest—'Please, come in, you're invited'—but of course as invited guest you won't disturb too seriously the order of the house, you're going to speak our language, eat the way we eat...et cetera et cetera. To this invitation, to this hospitality of invitation, I would oppose—or not oppose, but rather distinguish from it—the hospitality of visitation. The visitor is not an invited guest, the visitor is the unexpected one who arrives and to whom a pure host should open his house without asking questions such as: who are you? what are you coming for? will you work with us? do you have a passport? do you have a visa? and so on and so forth—that's unconditional hospitality.

We have here the same structure as we saw previously between the law and justice. They are absolutely heterogenous but indissociable. I cannot think of a conditional hospitality without having in mind a pure hospitality. I've been giving a seminar for several years on hospitality and we have studied a number of such historical examples of the manner in which a culture of hospitality organises itself. For instance, in pre-Islamic Arabic cultures the idea of hospitality had to do with nomadism, with people being in a

tent in the desert, and there were rules: if some traveller lost his way and arrived at the tent, they should receive him for three days, offering him food and bed and so on and so forth, but after three days that was the end. That was conditional hospitality and there is a language adjusted to these situations.

But to think of this conditional hospitality one has to have in mind what would be a pure hospitality to the messianic Other, the unexpected one who just lands in my country and to whom I simply say: come and eat and sleep and I won't ask even your name—which is another sort of violence, one of the many contradictions—because in principle if I want to pay attention to the Other and to respect the Other, I should speak to the Other, I should address the Other. Asking 'what is your name?' is not necessarily an investigation or an interrogation, as in the comment "Tell me your name". There are many ways of asking the name of the Other. One is the manner of the police and immigration when they ask 'show me your passport?', 'what are you doing?', 'what will you be doing in this country?' and so on. The Other is simply 'who are you?'. You see here the two poles of the conditional and unconditional hospitality, the just and the legal hospitality. And I would say once more that unconditional hospitality is impossible, because it is impossible to decide and to make a rule out of it, to decide that as a rule I'm going to open my house or open my nation, my country, to anyone coming for I don't know what reason. It's impossible to make that decision and people who say 'we'll do that' are certainly lying. It's impossible, but that's what hospitality should be, in principle.

Now, to come back to one of your most difficult questions: what room is left for a politics of hospitality in that case, for perfectibility? If I want to improve the laws—and this is a very concrete problem for everyone in the world today, and especially in Europe and in France—how can we improve the situation? For instance, France has been recently, and for decades, betraying laws on political asylum, practicing a politics of immigration which is untrue to its own principle and so on and so forth. So we have to

change the law, improve the law, and there is an infinite progress to be performed, to be achieved in that respect. I love the process of perfectibility, because it is marked by the context of the eighteenth century, the *Aufklärung*. It is often the case that people would like to oppose this period of deconstruction to the Enlightenment . No, I am for the Enlightenment, I'm for progress, I'm a 'progressist'. I think the law is perfectible and we can improve the law. We have to improve the conditions of conditional hospitality, we can change, we should change the laws on immigration, as far as possible, given a certain number of constraints.

For instance, in France—let me take this example to be less speculative and theoretical—some people, including me, have signed a petition saying that, in certain conditions, we were ready to shelter in our houses people who were considered illegal immigrants in France. We say, well, we are going to violate the law, to practice civil disobedience because we find the way that the government today applies the law is outrageous, but we are not simply doing this irresponsibly. The Minister of the Interior at the time said: 'these intellectuals are irresponsible, they are irresponsible because they want simply to open the gates and let everyone into the country, and then you will see what happens'. No, we didn't say that. We were not advocating an unconditional hospitality. We said that there is today a law, for instance embodied in the Declaration of the Rights of Man, there is a law which is higher than the French legal system, than the way it is currently applied. And it's in the name of this law, of this legality, that we oppose the current interpretation of the law by the French government. So it was not in the name of pure hospitality that we did so, but in the name of a perfectible law. We wanted the law to be changed and in fact, to some extent, it has been changed. It has been changed, but not enough. Of course, we were not charged. I myself, for instance, could hide some such immigrants, and they couldn't sue me. The government had to change, to some extent—not enough, but to some extent—its policy, its practice. So in that case we considered that the law was

perfectible, that we had to improve the law, without claiming that the unconditional hospitality should become the official policy of the government.

We are not dreamers, from that point of view, we know that today no government, no nation state, will simply open its borders, and in good faith we know that we don't do that ourselves. We would not simply leave the house with no doors, no keys and so on and so forth. We protect ourselves, OK? Who could deny this in good faith? But we have the desire for this perfectibility, and this desire is regulated by the infinite pole of pure hospitality. If we have a concept of conditional hospitality, it's because we have also the idea of a pure hospitality, of unconditional hospitality. The same goes for forgiveness. This resembles but is not identical with Kant's notion of a regulative idea: that is, there is an endless inadequation between the conditional and the unconditional, and there is this regulative idea...an inaccessible law. In fact, it's here and now that we have to try to think and to embody what unconditional hospitality should be. There is this intention and if we cannot conform to this injunction, and we cannot, obviously we cannot, it's impossible, it's impossible as a rule...

Let me try and make this more specific. It's impossible as a rule, I cannot regularly organise unconditional hospitality, and that's why, as a rule, I have a bad conscience, I cannot have a good conscience because I know that I lock my door, and that a number of people who would like to share my house, my apartment, my nation, my money, my land and so on and so forth. I say not as a rule, but sometimes, exceptionally, it may happen. I cannot regulate, control or determine these moments, but it may happen, just as an act of forgiveness, some forgiveness may happen, pure forgiveness may happen. I cannot make a determinate, a determining judgement and say: 'this is pure forgiveness', or 'this is pure hospitality', as an act of knowledge, there is no adequate act of determining judgement. That's why the realm of action, of practical reason, is absolutely heterogenous to theory and theoretical judgements

here, but it may happen without even my knowing it, my being conscious of it, or my having rules for its establishment. Unconditional hospitality can't be an establishment, but it may happen as a miracle…in an instant, not lasting more than an instant, it may happen. This is the…possible happening of something impossible which makes us think what hospitality, or forgiveness, or gift might be.

I wanted to say just one word about the example you gave when you say—I'm just re-reading your text—'In an Australian context this could have a particular resonance, as when John Howard disclaimed as not properly his the history of colonial violence in Australia, as if one would be responsible only from the starting point of that kind of property demarcation'. In that case, to go back to the question of inheritance and heritage, of course one can imagine why someone would say 'well, colonial violence occurred before I was born and I don't want to carry the burden of this responsibility'. There have been a lot of such claims in Germany with the young generation saying: 'I had nothing to do with Nazism, why should I feel guilty for that?'. Well, the fact is that we are responsible for some things we have not done individually ourselves. We inherit a language, conditions of life, a culture which is, which carries the memory of what has been done, and the responsibility, so then we are responsible for things we have not done ourselves, and that is part of the concept of heritage. We are responsible for something Other than us. This shouldn't be constructed as a very old conception of collective responsibility, but we cannot simply say: 'well, I, I wash my hands, I was not here'. If I go on drawing some benefit from this violence and I live in a culture, in a land, in a society which is grounded on this original violence, then I am responsible for it. I cannot disclaim this history of colonial violence, neither in Australia nor anywhere else.

That's the difficulty of the concept of responsibility—I'm going to end with this, missing a number of points that you made, as has been constantly the case today. What does it mean to be responsible? Usually one associates the concept of responsibility

with the concept of freedom, decision, action: I'm responsible for
what I freely decide, and I actively make or do, but again—to go
back for the last time to this aporia of the possible/impossible—if I
am responsible only for what I decide, and if I decide only what I
can decide, what I am—I, ego, am able, have the ability to decide,
the possibility to decide, then it is not a decision. If the decision fol-
lows my ability to decide, if I decide what I can decide, I say: 'well,
I can do that, I do that, I am able to do that, I do that', this is not a
decision. If I do what I can do, it is not a decision. So that is a terri-
ble paradox, that is what blows up, explodes these traditional con-
cepts. The decision, in order to be a decision, however mad it may
sound, or crazy it may sound, a decision, my decision should not be
mine, it should be, as impossible, the decision of the Other, my
decision should be the Other's decision in me, or through me, and I
have to take responsibility for the decision which is not mine. When
I say 'it's not mine' I mean that which exceeds my own being, my
own possibility, my own potentiality. If you describe an individual
as a set of possibilities, a set of capacities, a set of predicates—I am
this or that, I am the one whom you can describe as being this or
that, that is an assemblage of attributes or predicates—and if the
decision is simply the consequence or what follows from this set of
possibilities, then it's not a decision. A decision should be some-
thing more than what is simply possible...what follows from the
predicate of possibilities, what defines my definition. If I decide, if
my decision is my definition, if by my definition of myself I make
such or such a decision, it's not a decision. So, the only possible
decision is the impossible decision, the decision which is stronger
than me, higher than me and coming from the Other, from the order
of the Other, that is heteronomy. The Other orders me to take this
decision, which nevertheless remains free. It's free and I'm not
exonerated from responsibility because it is the Other's decision. I
realise how mad this language may sound, but perhaps that it
because decision is madness. A decision which is simply a wise
decision... what is a wise decision? If I...take the 'wise decision',

it's...I can ask my computer to calculate the wise decision, OK? But a decision is never wise, it should not be wise, it should remain incalculable, incalculable. [applause]

Open Discussion

Desmond Manderson:

P rofessor Derrida, I want to ask a question which draws our discussion this afternoon into some of the issues you canvassed yesterday, particularly in your comments on *Memoirs of the Blind*. The hospitality shown by the English to the French goes back to at least the Norman Conquest in 1066. One effect of that conquest was to create a legal system based entirely on linguistic misunderstanding and mistranslation. In the aporia between Norman French and Old English, a space emerged which was called the common law and which allowed, for a time, a freer exploration of justice. Now, that space was founded on an act of violence and death, namely the Battle of Hastings and, in a drawing which gave those acts a diachronic or textual form and a mythic character, the Bayeux Tapestry legitimated the new sovereignty literally by blinding the old, Duke William's arrow piercing King Harold's eye. This suggests to me something about the legal and constitutive power of images, but it also makes me wonder whether the familiar image of justice as blind represents more than simply a paradoxical representation of pure objectivity but draws us instead into deeper realms of blindness in the law. I wonder if you'd care to comment on any of these themes.

Derrida:

Ah, it's a very...rich hypothesis and...despite the fact that I am totally incompetent on the details of this tapestry, the logic that you follow here seems to me to be very legitimate...I don't know how to account historically for this representation. I don't know why we often represent justice as blind, probably as an act of scepticism or disbelief in justice. But we could interpret it differently, according to what I tried to suggest today and in the other text, namely that justice is and has to be foreign to a certain kind of reasoning, of reason, of calculation, of calculation, of reasonable calculation. Justice should be blind, in a certain way. It should be mad, as I said. You obviously recognised the quotation when I said, at the end of the session a moment ago, that decision is mad, the wise decision is not a decision. I was quoting someone I often quote, namely Kierkegaard, who said: 'the instant of decision is mad'. From that point of view, justice must be mad too, and blind. That is, it should close its eyes to the conditions, to the legal system. Justice is something which exceeds some sort of reason, which doesn't mean that justice is irrational, but that justice is not simply the lucid or the reasonable analysis of the conditions. So in a certain way when I want to be just with the Other, I should simply exclude every kind of theoretical analysis: justice is not theoretical. If theory is seeing, as we said last night— *theorein* means to see, to contemplate—if theory means seeing, something like justice should be blind since it is trans-theoretical, so to speak. To that extent, if this is your hypothesis, I would agree. Now this doesn't mean necessarily that the people who draw justice with something on the eyes had this in mind. But if this is what you have in mind, I would agree with you.

Leslie Stern:

I have a question about your involvement in the International Parliament of Writers and in particular about a piece you have written about Abu-Jamal, who is the longest serving prisoner on death

row in the United States. His case is of course very particular, given his own history and the political history of his case. But, I guess, he also serves as a typical case. My question is: what is it possible for writers in this Parliament to do, can we make things better? And secondly: what is the impossibility of the situation? Surely the very existence of this body is posited to some degree upon the impossibility of writing itself, or at least a blockage of writing, writing that goes nowhere, that ends up in prison?

Derrida:

I am not sure I understood the last point, but we will come back to this. As for Mumia Abu-Jamal, the fact is that, exactly at the moment that the International Parliament of Writers was founded, we published his book in French translation and I wrote the preface in which I protested against the situation. We asked—more than once—for the revision of his trial, of his judgement...I don't know if all of you are familiar with this case, Mumia Abu-Jamal was a young journalist and formerly a member of the Black Panthers in the United States. He was charged with the murder of a policeman, and he always denied having done so, and he was sentenced to death, in 1982 I think or 1983. Since then there have been a lot of legal procedures and he is constantly threatened with execution. We did our best to not simply prove his innocence but to ask for the revision of his trial, because there were so many obvious irregularities. I even wrote, with Marie-Claire Mendès-France, to Mr and Mrs Clinton to ask for their intervention, but so far we have had no answer. I realise when I am in the States that the majority of my American colleagues and friends don't even know about this terrible case. So we do what we can, and it's not enough...I always have a bad conscience because I think we don't do enough to make this case public and to call for the help of many other intellectuals and non-intellectuals and so on and so forth. So that's the limit of our action.

I don't know whether everyone in the audience knows what this International Parliament of Writers is. It's an institution which was founded four or five years ago in order to help people, intellectuals in the broad sense, journalists, writers or people who in fact speak or want to take responsibility in the public space and who are, for that reason, persecuted or threatened in their own country. We try to open what we call 'city refuges': a number of cities sign an agreement with us in which they commit themselves to offer hospitality to these people, to give them a house, money and conditions of work in the city.

But what I missed in your question was the point about the impossibility of writing. Mumia Abu-Jamal, at the beginning, could write, that is, publish, while in jail. After a certain point he was denied the possibility of writing, it became impossible for him, if not to write at least to publish, and of course one of our demands was that this possibility would be given back to him. The United States is a terrible country, not only because the death penalty is still valid, but because it is more and more often enforced, even in states which had for some time tried to suspend, not the death penalty itself, but the executions, the enforcement of the death penalty. So, it's the only so-called democratic country in the world which maintains the death penalty—not only maintains it but creates conditions of incarceration and execution which are the most cruel in the world today. And if we come back from this situation of the death penalty in the United States to the question of colonial countries: it is because it's still a colonial country, because of what remains from slavery, from all the past of colonisation that they cannot abolish the death penalty in the way that all the democratic countries in Europe have done. It's an obligation now to abolish the death penalty. So today I think the death penalty is one of the most revealing issues about the state of a society. I don't know what the situation is in Australia, is it abolished?

[Paul Patton: 'Yes, it is abolished. There is no death penalty']

So, I don't know what you meant by impossibility here...this impossibility of writing has nothing to do with the impossibility that we referred to during the discussion today. It is the interdiction of writing to which he is subject, it's not the impossibility of writing, unless I missed the meaning of your last question.

Vicki Kirby:

Professor Derrida, I make the obvious point that you've been brought here under the auspices of several quite predictable disciplines within the academy: visual arts, literature, philosophy. These are disciplines where deconstruction has been given a home, albeit a very uneasy one. Clearly, within the academy there are many disciplines where deconstruction's way is blocked, where it does encounter aporia, for example anthropology, about which you've written. So, in acknowledgment of this division and the way in which deconstruction has been taken up in certain places within the academy, but not in others, I'd like to talk about the way in which the notion of the general text has been conflated with 'there is no outside of culture' in such a way that it appears consistent with those disciplines where deconstruction has a home. For example, one could see the connection between or the resonances with a notion of a general text in genetics, cybernetics, post-quantum mechanics, but in these fields, it's as if deconstruction is not picked up in any way, as if language is indeed language in the restricted sense, or language in the general sense is merely culture in the narrow sense.

Derrida:

I think I have no general answer to this question. In each case you would have to reconstitute not only the history of the discipline but the history of the local institution of the discipline. For instance, take the example of departments of literature or literary theory:

apparently, these have been more hospitable to deconstruction in certain countries but not in others. In France, for instance, departments of literature haven't been hospitable to deconstruction, whereas in the United States they have been, at least more than in France. This has to do with the history of criticism in the United States, with the history of New Criticism, with the history of the link between religion and literature, with philosophy and religion and theology in the American academy and so on and so forth. That would require a long and detailed analysis to account for the different situations in different disciplines, different countries and so on and so forth, so I cannot really provide a general answer to this.

Now, to refer to the point that you made that in some disciplines, such as genetics, in which the idea of a general textuality is more easily acceptable, nevertheless there is no deconstructive genetics. This leads us to think that the methods of deconstruction, the language of deconstruction, the procedures—there is no method but there are some methodological schema—are necessarily constituted there precisely where this general textuality or this unlimited concept of textuality is not considered evident. What you need deconstruction for is to undo a number of presuppositions, prejudices and so on and so forth. But where you don't need to undo such things, you don't need deconstruction. If this is the case ... it is not purely the case, even in genetics, because what is genetics? there is of course what we call the scientific content of genetics, and there is also interpretation, a discourse and ideology of genetics, and I am sure that on this layer of the ideology or the epistemology of genetics one would need deconstruction. I don't know if deconstruction is practiced but I am sure that one would need some deconstructive questions. So it depends on the type of relationship that you have between interpretation and knowledge, and of course the more you rely on interpretative languages, on institutional practices and so on and so forth, the more you need deconstruction.

Now, as for the reasons why it is better received 'here' than 'there'...I have no general answers. I have some ideas about the

United States. The United States is not simply one country among others since once something occurs in the United States, indirectly, in a slightly different way, it happens in all the world, firstly through the English language and through other mediations. But I can't answer in a general way. There are also the problems of democratisation, decolonisation, sometimes ... at a certain moment of a process of democratisation or decolonisation, deconstruction is helpful, sometimes it is considered negative and incompatible with the process of democratisation, it depends. In each case this would require a very refined analysis.

Elizabeth Wilson:

I'd like to ask a question about the human. Can you say something about whether the issues that have been discussed here today—for example, mourning or hospitality—can or cannot be contained or governed by the human, or are there non-human modes of hospitality or mourning?

Derrida:

That's a very difficult question. First of all, if I want to go directly to the extreme, I would say that what I call unconditional hospitality is not necessarily human. It must be, or it should be, or it can be offered to non-human beings, to Gods, or animals, or plants. If you ask the Other one to be human before you open your door, then that is a condition. Of course, in the Jewish-Christian biblical concept of hospitality, you owe hospitality to your neighbour, your *prochain*, that is, to the one who is a human creature created by God as a brother or a sister—that is, as a human similar to yourself, a human who resembles you, as being a member of God's family. Even the Paulinian concept of cosmopolitanism implies that all men and women are brothers, that is, sons of God and that is the condition of hospitality. We have to be hospitable to human beings. They often think that we have to be unconditionally hospitable to any human

being, but not necessarily to animals, plants, and so on and so forth. And that is a problem. Should we offer hospitality to visiting animals? To unexpected living beings—not only my cat, but my neighbour's cat [laughter], and the unknown cat? If, when an unknown cat comes you close the door, you have a good conscience, well, that's your problem, I don't, OK?...Of course, if it's a lion [laughter]...I'm just pointing out that there are problems, OK?

But each time we mentioned unconditionality and madness today, we were challenging the idea of humanity, the limits of humanity and thus the limits of humanism. Which, again, doesn't mean that we are against humanity, against humanism, but simply that we are not sure of what humanity means if we don't trust all the assumptions about what is proper to man. There are a number of such assumptions about what is proper to man. We could spend hours and hours to establish an endless list of predicates of what is proper to man, and I am sure that all of them are problematic, to me, all of them. Which means that I've nothing against man, but I am not sure I know what the essence of man is, what is proper to man. If man is a perfectible creature, that is, if the identity of man is something 'to come', then the limits of humanity are not given. If one, for instance, to take this example—I limit myself to the most obvious thing—if one changes the Declaration of the Rights of Man, and one considers, after one century, that the Rights of Man are not limited to this but should be extended to that, it means that man is something else than what we thought at the end of the eighteenth century. And that something could happen or should happen, that something is 'to come' as to what man is. So from that point of view, to be suspicious about the limits of man is not to be anti-humanist, on the contrary, it's a way of respecting what remains 'to come', under the name and the face of what we call 'man'. You have to be more and more human, and it's not obvious what it means. We are not human enough, we are never human enough, so from that point of view unconditional hospitality is not restricted by

what one knows under the name of man or what is proper to man. We have to be hospitable to what is coming, and to a new figure, a new shape of what one calls humanity. So that is what it may mean to be hospitable to more than what is human today. That is why it's a very difficult and important question. And, of course—if I had time—I would insist more than that on the animality, which for me is a very obsessive problem, an enormous and difficult problem today, the way we, the way man, humanity, deals with animals, with what one calls 'the animal'. There is no such thing as 'animal', there are an infinite number of different animals and the problem of hospitality is also the problem of our relationship with these living beings we call animals. But that's a minimal answer.

Tom Morton:

I want to ask you a question about our relationship with technology. You talked about the way in which technology is both an Other for us, something of which we're often afraid, but it's also part of us, and in a very real sense it's what we make in our own image. Does that mean that it's time for us to begin thinking about the need for an ethical relationship between humanity and technology, and perhaps even the notion that machines have rights, and we have responsibilities towards them?

Derrida:

Of course, if the question is: do the machines, understood in the trivial sense, have rights, the answer is no, OK? A machine as such has no rights, it's not a person. But this is not what one calls a machine. If our body is immediately connected with machines and if machines are part of our body, memory, culture, and so on and so forth, we cannot dissociate between the instrument and the body or the society, then machines have rights. And that is why if you destroy in a culture everything which is mechanical, all the instruments, all the technology, it is murder, it's a murder, it's a crime. If

you take into account this strange and at the same time meaning-less, insignificant *and* meaningful relationship between the machine and the technology and the body, the human body or the living body, then you owe some respect to technology. Of course, we constantly destroy some machines, but what do we destroy? If, for instance, I destroy an individual computer, because it's useless or it's old-fashioned, I don't destroy the technology, I destroy something which is useless. I don't destroy the device. I don't destroy the logic of the instrument. If we consider the logic of the instrument as an invention, as something which is closely related to a body, to what I would call a soul or a spirit, then to that extent I owe respect to the technological invention. That is what I should not destroy. We have museums, archives, or museums of old technologies, because they are testimonies of a culture. We keep the locomotives and old cars and old typewriters—Nietzsche's type-writer, we have to respect Nietzsche's typewriter...it's part of the body of Nietzsche. That's part of fetishisation...all this is a problem of fetishisation.

Caroline Schaeffer-Jones:

Professor Derrida, I refer to your book *Donner la mort*, published in French this year. Is there a relationship between the pardon, specifically the sacrifice of Isaac, and a certain laughter of Bataille. Would you comment on this and on desacralisation?

Derrida:

Well, it's a vast beehive of questions. And I'm not sure that every-one here here has read this short book of mine, *Donner la mort*, so how could I answer in a way which would be intelligible to all of you? David Wills has translated the first version of *Donner la mort*, the gift of death—which was not published as a book in France—and I then published a book in France, a new version adding a chapter, to which you refer.[42] In this new chapter, following

Kierkegaard, I ask some questions about forgiveness and the secret in literature, and one of the threads that I follow leads from the situation in which Abraham on the Mount Moriah, when he was about to sacrifice, as they say, Isaac, had to keep it secret. God submitted him to this ordeal; that is, not only 'you should kill your son', but most of all 'you should keep it secret'; that is, do not tell this to Sarah, to your wife, to the community. Then Kierkegaard says that Abraham—that's a poetical fiction on the part of Kierkegaard— asked for forgiveness from God, not for having disobeyed him, but for having obeyed him. I cannot reconstitute the whole scenario here, but I follow this thread and tie the question of responsibility to the question of the secret, as if every decision, every responsibility had to be kept secret or to involve the absolute singularity and secrecy of the one who takes the responsibility. I tried to show that what one calls literature, in the modern sense of the word, inherits this biblical situation, this Abrahamic situation.

One usually thinks that literature, I mean the modern concept of literature, the modern institution of literature, is a secular institution, that it is desacralised. I tried to show that in fact literature keeps a secret filiation with this sacred, sacrificial situation and asks for forgiveness, that every literary text in a certain way asks for forgiveness for betraying this filiation, for betraying the sacredness from which it comes. I cannot reconstitute this chapter because I play with a certain sentence of Abraham which says: 'Forgive me for not meaning anything'—'*Pardon de ne pas vouloir dire*'. Abraham who has to keep secret his absolute singular relationship to God, and he has to exceed the norms of what Kierkegaard calls generality, ethics, the laws of the city and the family and so on and so forth. So he has to keep this secret to be forgiven for keeping this secret, for not being willing to say, or meaning to say, or being able to say.

I think the situation in literature is analogous, that is, literature is a way of suspending the reference, of not of being able to say everything. That's why literature is indissociable from democ-

racy: under the name of literature you can, you should be able to publish anything you want, with no restrictions, no censorship, in principle. At the same time you could keep everything secret: that is, while publishing you could hide whatever you want, you don't have to mean something. So, in that respect there might be a tradition going from the Abrahamic situation to literature and thus at the same time...a continuation and a betrayal of the sacred situation. That is why secularisation in literature doesn't mean anything to me. I think literature remains to us, for us, a sort of sacred space, and we have to interrogate what this sacredness, this secularised sacredness may mean. In the course of this chapter I take examples—for instance Kafka's letters to his father...scenes of forgiveness, forgiveness for writing literature. There is this extraordinary letter to his father by Kafka, in which—I cannot begin to reconstitute this—Kafka is charged by his father, but where his father here is speaking through his own voice or his own pen...he is charged by his father for being unable to get married—like Kierkegaard— and for being good only for literature, living like a parasite, like a useless parasitical being, because he just writes literature. So literature is unforgivable, literature asks for forgiveness, as unforgivable.

So, to return to your question: I would never oppose secularisation to sacredness, because I think that the concept of secularisation is a religious concept, it belongs to a tradition of religious culture. When we have what one calls a 'secularised' something, a secularised concept, it means that it remains religious. Let me take a last example before we conclude, an example in which I am very much interested now, the concept of sovereignty, for instance, the sovereignty of the state. It was at the beginning a religious concept; that is, God, the Almighty is sovereign. Then, in absolute monarchies, the king was sovereign, that is, almighty by virtue of God, because God gave him this power. Then this concept of sovereignty became, as one says, secularised, that is, one could, with Rousseau for instance, say that people in a democracy, in a republic, the people become sovereign, and in principle without depending on God

for this sovereignty. But if you read Rousseau closely you will see that there is something sacred—and that's Rousseau's word—in the people's sovereignty, in the democratic or republican sovereignty of the people. So here you have a concept which is in principle secularised, but for which the very secularisation means the inheritance of a theological memory. It is a theological phantasm or concept. When, for instance, Carl Schmitt says that all the political concepts, all the concepts of the political, in Western society are secularised theological concepts, that is what he means: that our culture lives on secularised sacred concepts, secularised theological concepts. Even the current stage of, let's say, democracy, not to speak of absolute monarchy, of inherited monarchy, but even the concept in which one defines the nation state, the modern nation state, the modern democracy—these concepts are still theological, they are still tied to the idea of sovereignty which is a theological heritage, a religious heritage. That's why when I refer to democracy 'to come' I am referring to a democracy which would transform itself precisely by interrogating, in some sense deconstructing, the limits of these onto-theological concepts, for instance. That's why we cannot simply be certain that our secularised concepts are simply secularised, and not sacred, so there is a sacredness…should we get rid of every sacredness? That's another problem, I'm not sure. I think we haven't exhausted the problems but we are certainly exhausted for today. [applause]

Notes

1. Jacques Derrida, *Memoires: for Paul de Man*, trans. Cecile Lindsay, Jonathan Culler, Eduardo Cadava and Peggy Kamuf, New York: Columbia University Press, 1986.
2. Jacques Derrida, *Politics of Friendship*, trans. George Collins, London and New York: Verso, 1997.
3. Jacques Derrida, *Sauf le nom (Post-Scriptum)*, trans. John P. Leavey, Jr., appears in *On The Name*, ed. Thomas Dutoit, Stanford: Stanford University

Press, 1995, pp.35-85.

4. Martin Heidegger, *Letter on Humanism* in David Farrell Krell ed. *Martin Heidegger: Basic Writings*, rev. and expanded ed., New York: Harper Collins 1977; London, Routledge, 1978.

5. Jacques Derrida, *Fors: Les mots anglés de Nicolas Abraham et Maria Torok*, foreword to Nicolas Abraham and Maria Torok, *Cryptonomie: le verbier de l'homme aux loups*, Paris: Aubier-Flammarion, 1976, pp.7-73. *The Wolf Man's Magic Word: A Cryptonomy*, trans. Nicholas Rand, Minneapolis: University of Minnesota Press, 1986. Derrida's foreword translated by Barbara Johnson as 'Fors: The Anglish Words of Nicolas Abraham and Maria Torok', *Georgia Review*, 31 (1), 1977, pp.64-116.

6. Edmund Husserl, *Cartesian Meditations*, trans. Dorion Cairns, The Hague: Martinus Nijhoff, 1960.

7. Derrida, *On The Name*, pp.43-44.

8. Jacques Derrida, 'Force of Law' in Drucilla Cornell et al eds *Deconstruction and the Possibility of Justice*, New York and London: Routledge, 1992.

9. Jacques Derrida, *Specters of Marx: The State of the Debt, the Work of Mourning, and the New International*, trans. Peggy Kamuf, London and New York: Routledge, 1994; *Échographies:de la télévision*, with Bernard Stiegler, Paris: Galilée- INA, 1996.

10. Jacques Derrida, 'Faith and Knowledge: the Two Sources of "Religion" at the Limits of Reason Alone' in *Religion*, ed. Jacques Derrida and Gianni Vattimo, Oxford and Cambridge, Mass.: Polity Press, 1998, pp.1-78.

11. Derrida, *Échographies*, p.33.

12. Jacques Derrida, *The Other Heading: Reflections on Today's Europe*, Bloomington and Indianapolis: Indiana University Press, 1992; *Aporias*, trans. Thomas Dutoit, Stanford: Stanford University Press, 1993; *Parages*, Paris: Editions Galilée, 1986; 'On a Newly Apocalyptic Tone in Philosophy', trans. Tim Leavey Jr., in *Raising the Tone of Philosophy*, ed. Peter Fenves, Baltimore and London: Johns Hopkins University Press, 1993, pp.117-171.

13. Derrida, *Specters of Marx*, p.89.

14. See above p.43

15. Derrida, *Échographies*, pp.99-100.

16. Translation in the text by David Wills. See 'Faith and Knowledge' p.47.

17. See David Wills, *Prosthesis*, Stanford: Stanford University Press, 1995.

18. Derrida, 'Force of Law', p.15.

19. Derrida was reported as saying that the Federal Government should

apologise to Aborigines for past injustices. See *The Australian,* Tuesday 10 August 1999 p.6, and above p.4. *Monolingualism of the Other; or, The Prosthesis of Origin,* trans. Patrick Mensah, Stanford: Stanford University Press, 1996.

20. *Mabo v Queensland No. 2,* 1992, reported at 175 CLR 1; 66 ALJR 408; 107 ALR 1. The judgement is also published in book form, with commentary by Richard H. Bartlett, as *The Mabo Decision,* Sydney: Butterworths, 1993.

21. Derrida, 'Force of Law', p.16.

22. Derrida, *The Other Heading,* p.71.

23. Derrida, *Aporias,* p.19.

24. Ibid. p.19.

25. Derrida, 'Force of Law', p.16

26. Derrida, '*La Littérature au secret*' in *Donner la mort,* Paris: Galilée, 1999. p.170.

27. Derrida, 'Force of Law', p.5.

28. Derrida, *Monolingualism of the Other,* p.10.

29. Derrida, '*Question d'étranger: Venue de l'étranger*'; '*Pas d'hospitalité*' in *De l'hospitalité,* with Anne Dufourmantelle, Paris: Calmann-Lévy, 1997 (translated by Rachel Bowlby as Jacques Derrida and Anne Dufourmantelle, *Of Hospitality: Anne Dufourmantelle Invites Jacques Derrida to Respond,* Stanford: Stanford University Press, 2000); '*Fidélité à plus d'un*' in *Rencontre de Rabat avec Jacques Derrida: Idiomes, nationalités, déconstructions, Cahiers intersignes* no. 13, 1998; '*Une hospitalité à l'infini*'; *Résponsabilite et hospitalité*' in *Autour de Jacques Derrida: Manifeste pour l'hospitalité,* Paris: Paroles de l'aube, 1999.

30. Derrida, *Autour de Jacques Derrida: Manifeste pour l'hospitalité,* p.98.

31. Ibid:, p. 100.

32. Derrida, *Of Hospitality,* p.29.

33. Derrida, '*Fidélité à plus d'un*', p. 227.

34. Derrida, *De l'hospitalité,* p. 53.

35. Jacques Derrida, *Cosmopolites de tous les pays, encore un effort!* Paris: Galilée, 1997. p 13-14, 12-13.

36. Derrida, '*Fidélité à plus d'un*', p. 260.

37. Derrida, *Cosmopolites de tous les pays, encore un effort!.* p.42.

38. Derrida, '*Fidélité à plus d'un*', p. 259 and see *Monolingualism of the Other,* p.39.

39. For John Caputo's discussion of hospitality, see John Caputo, *Deconstruction in a Nutshell: A Conversation with Jacques Derrida.* New York: Fordham University Press, 1997. pp109-113. Caputo relates

Derrida's discussion of hospitality's etymology to that of Emile Benveniste. See Emile Benveniste, *'L'hospitalité'* in *Le vocabulaire des institutions indo-européennes I*, Paris: Ed. de Minuit, 1969, pp.87-101.

40. Derrida, *Autour de Jacques Derrida: Manifeste pour l'hospitalité*, p.105.

41. Derrida, 'Fidélité à plus d'un', p. 258.

42. Jacques Derrida, *The Gift of Death*, translated by David Wills, Chicago and London: The University of Chicago Press, 1995; *Donner la mort*, Paris: Galilée 1999 (the additional text referred to is *'La Littérature au secret'* cited above n.26).

NOTES ON CONTRIBUTORS

Professor Jacques Derrida taught for many years at the École Normale Supérieur and then until his retirement at the École Des Hautes Études En Sciences Sociales in Paris, and at a number of American Universities including Yale, Cornell and the University of California at Irvine. His published work since the early 1960s has provoked widespread interest and debate throughout the humanities and social sciences, but especially in philosophy, literary criticism, film and cultural studies, visual arts and theology. Derrida has written about philosophers from Plato and Aristotle to Condillac, Kant, Rousseau, Hegel, Husserl, Nietzsche, Marx, Freud, Heidegger and Levinas, and about literary and artistic figures such as Mallarmé, Joyce, Kafka, Valéry, Genet, Ponge, Célan, Artaud, Blanchot and de Man.

Dr Penelope Deutscher, Associate Professor in Philosophy at Northwestern University. Her recent publications include *Yielding Gender: Feminism, Deconstruction and the History of Philosophy* (Routledge, 1997); with Kelly Oliver, editor of *Enigmas: Essays on Sarah Kofman* (Cornell University Press, 1997); *Politics of Impossible Difference: The Later Work of Luce Irigaray,* (Cornell University Press 2002).

Genevieve Lloyd, Professor Emeritus of Philosophy at the University of New South Wales, Sydney. Her recent publications include *Being in Time: Selves and narrators in philosophy and literature* (Routledge, 1993); *Part of Nature: Self-Knowledge and Spinoza's Ethics* (Cornell University Press, 1994); *Spinoza and the Ethics* (Routledge, 1996); with Moira Gatens, *Collective Imaginings: Spinoza, Past and Present* (Routledge, 1999).

Paul Patton, Professor of Philosophy at The University of New South Wales. He translated Deleuze's *Difference and Repetition*

(Columbia, 1994) and Baudrillard's *The gulf war did not take place* (Power/ Indiana, 1995). He is the editor of *Nietzsche, Feminism and Political Theory* (Routledge 1993), *Deleuze: A Critical Reader* (Blackwell, 1996), and one of the editors of *Ivison,* Patton, Sanders eds *Political Theory and the Rights of Indigenous Peoples* (Cambridge University Press 2000). His most recent book is *Deleuze and the Political* (Routledge, 2000). He is currently editing (with John Protevi) a collection of comparative studies entitled *Between Deleuze and Derrida,* to be published by Continuum Press in 2002.

Terry Smith, Power Professor of Contemporary Art at the University of Sydney and Director of the Power Institute, Foundation for Art and Visual Culture, at the University of Sydney, Australia, from 1994 to 2001. He is currently Andrew W. Mellon Professor of Contemporary Art History and Theory at the University of Pittsburgh. During 2001-02 he is a Getty Scholar at the Getty Research Institute, Los Angeles. His recent publications include *Figuring the Ground: Landscape, Colony and Nation in Nineteenth Century Australian Art* and *Transformations: Aboriginality and Modernism in Twentieth Century Australian Art*(Craftsman House, 2001) and, as editor, *Ideas of the University* (Research Institute for the Humanities and Social Sciences, University of Sydney, 1996), *In Visible Touch* (Power Publications and University of Chicago Press, 1997), and *Impossible Presence: Surface and Screen in the Photogenic Era* (Power Publications and University of Chicago Press, 2001).

David Wills is professor of French and chair of the Department of Languages, Literatures and Cultures at the University at Albany (SUNY). Recent publications include *Prosthesis* (Stanford University Press, 1995) and the translation of Jacques Derrida, *The Gift of Death* (University of Chicago Press, 1995). He is currently preparing a collection of essays on Derrida for Stanford University Press.